CRAFTING
A
BETTER
WORLD

CRAFTING
A BETTER
WORLD

INSPIRATION AND DIY PROJECTS
FOR CRAFTIVISTS

DIANA WEYMAR

CREATOR OF *TINY PRICKS PROJECT*

HARVEST
An Imprint of WILLIAM MORROW

JUN · 79

for Matthew,
Tobias, Macy,
Liza & Alden —
you are my
better world

xo

DW

CONTENTS

An Introduction and an Invitation ix

CRAFTING LIFE

CRAFTING A CALL TO ACTION:
Jamie Lee Curtis, Actor, Activist 3

CRAFTING CONNECTION:
Suleika Jaouad, Author 7

CRAFTING ANXIETY INTO ART:
An Interview with Roz Chast,
Cartoonist 15

THE CRAFT OF CAPTURING
CLIMATE AT SEA: The Work of Camille
Seaman, Activist Photographer 21

CRAFTING A "LIFE-IS-GOOD"
COLUMN: An Interview with
Maira Kalman, Artist, Illustrator,
Writer, Designer 25

POSTER GIRLS: Guerrilla Activism
and Art: The Guerrilla Girls,
Activists 31

STITCHING OUT OF DARKNESS:
Rachelle Hruska MacPherson,
Founder of Clothing Brand
Lingua Franca 35

CRAFTING LOVE: Alexandra Grant,
Founder of grantLOVE Art Nonprofit,
Cofounder of LOVE Cookie Craft, and
Victoria Knight, Chef, Cofounder of
LOVE Cookie Craft 41

ESSENTIAL QUESTIONS:
Steve Leder, Senior Rabbi of Wilshire
Boulevard Temple in Los Angeles 45

PROPAGATION PRACTICE:
Tanya Selvaratnam, Artist, Author,
Producer 47

WHEN THINGS FALL APART
WE SING: Afro-Indigenous Ecotherapy
Practices for Wellness: J. Phoenix Smith,
Ecotherapist 51

FIGHTING FIRE WITH FIRE:
Adapting Indigenous Practices:
Dr. Kira Hoffman, Fire Ecologist 55

WELCOME BLANKET:
Jayna Zweiman, Activist, Cofounder of
Pussyhat Project 59

BANNING TOGETHER AGAINST
BANNING BOOKS:
PEN America, Nonprofit, and
Ash + Chess, Artists 65

CRAFTING A HISTORY OF LOVE:
Tiya Miles, Author, Public Historian 69

LOVING THE THREAD:
Natalie Chanin, Entrepreneur,
Fashion Designer, Founder of Alabama
Chanin and Project Threadways 75

THE CRAFT OF BECOMING AND
BEING: An Interview with Rosanne
Cash, Musician, Author 81

CRAFTING A SOCIAL JUSTICE
BANNER: Sara Trail, Founder of
Social Justice Sewing Academy,
Nonprofit 89

CRAFTING A HEART:
Gisele Barreto Fetterman,
Activist, Philanthropist, Nonprofit
Executive 95

CRAFTING CONVICTION INTO
ACTIVISM: Nadya Tolokonnikova,
Member of Pussy Riot, Activist,
Performance Artist 103

LIKE CRAFT FOR CHOCOLATE:
Furious Vulvas: Lagusta Yearwood,
Chocolatier 109

CREATING AND CURATING
YOUR OWN ART GALLERY:
Danielle Krysa, Artist, Creator of
The Jealous Curator 113

CRAFTING LIGHT
WITH STAINED GLASS:
Washington National
Cathedral Windows:
Kerry James Marshall, Artist 117

CRAFTING A WEB OF WORDS:
Charlotte Clymer, Activist 121

CRAFTING A NEW ARGUMENT:
An Interview with Gabrielle Blair,
Designer, Author 125

CRAFTING! CURATING! COSTUMES!
A STAR IS BORN: Rebecca Seaver,
Creative+Production+
Design+Nashville 135

CHALLENGING TIMES, CREATIVE
MEASURES: *Tiny Pricks Project*:
Diana Weymar 139

CRAFTING MY WORLD

CONCLUSION: What Do We Make
from Here? 161

Partners in Thread 164

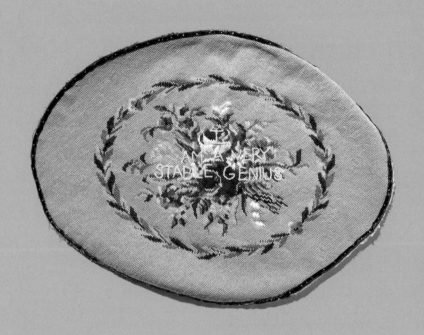

AN INTRODUCTION AND AN INVITATION

In a time of destruction, create something.
—MAXINE HONG KINGSTON

It all started with a tiny stitch and a big prick. For the first two years of the Trump presidency, I watched in quiet dismay as he assaulted every aspect of our democracy and our decency. He felt anathema to the aspirations for my practice as an artist. I was deeply engaged in studio and public stitching projects that used textiles for personal expression, grassroots community building, and the general betterment of society. I felt the power of the medium to capture emotions, narratives, and context.

I didn't want anything to do with Trump until he said, "I am a very stable genius." I knew immediately that this was great material: garish, ridiculous, delusional, horrifying, and hilarious. I pulled a needlepoint cushion cover out of a storage box of textiles inherited from my mother's family. The background was an indescribable mustard/gold color, the center infused with a cluster of grand, gaudy flowers, and

the edges rough, unfinished. In other words, it was the perfect textile for a little subversive craftivism! While my husband drove, I sat in the passenger seat furiously stitching "I AM A VERY STABLE GENIUS" with bright-yellow embroidery floss into my family heirloom. My "craft on the go" was done by the time we reached our destination about an hour later, and I felt deeply satisfied that I had scratched an annoying itch! I quickly took a picture of it, posted it to my personal Instagram account of a few hundred followers, and unknowingly launched *Tiny Pricks Project*, an international textile-based public protest art project. A couple of things about that moment: It was pure impulse. Trump had been pricking away at my sanity, and I needed a way of pushing back. I studied writing in college and worked in film for almost a decade in New York City, so I was sensitive to how language and imagery are used. *How they make us feel.* I also needed an activity that fit into my busy lifestyle. Convenient. My friend Dani Shapiro once referenced "retroactive intentionality" on one of her podcasts, and I want you to know that this was a case of retroactive *un*-intentionality. I believe that nothing is an accident, but sometimes creative impulses come from an unknown, unknowable place. And that can be a beautiful thing.

Six years, over six thousand posts, hundreds of contributors, more than five thousand textile pieces, and thousands of followers later, this book is in your hands! *Tiny Pricks Project* has evolved. Nowadays, my practice is devoted to creating a daily material record of current political discourse, popular culture, and artistic inspirations, and to raising awareness around issues that matter to me. In short, I cannot stitch fast enough to keep up with the material! I'm one of many artist-activists who could be categorized as part of the larger "craftivism" (craft + activism) movement, but whether we are stitching

a politician's quotes into family heirlooms, or sewing face masks during the COVID-19 pandemic, or knitting pussyhats, or engaged in a creative approach to a problem, we are crafting a form of resistance and a form of healing.

I have created large-scale public art projects, worked with peacebuilders, generated content for political campaigns, reported the news, and collaborated with other artists and activists. For the past decade, I have stitched my way through presidencies, current events, tragedies, my thoughts, and loss. For my children, I have used textile and thread to weave a story about the world we're in, how I see it, and what I hope for it. This is a form of documenting in real time. I hope this book shows you that making does not require you to drop everything in your life to clear space for it. It is what happens while you are living. It is a way of life.

This book is about creative work, and trying to make the world a better place. If you let it, it will take you by the hand and lead you to a place of your own unique making. We know a song by hearing it. We know clothing by wearing it. We know art by feeling it. We know a book by reading it. I know a better world by crafting it with others. Please join us.

✗ ✗ ✗

THIS IS A SMALL HANDBOOK that offers useful and helpful information about crafting and being crafty in general. When I set out to write about craftivism, I wanted to gather together a diverse group of people who showcase courage, unique voices, practice, projects, and imperfect offerings. They are some sources of my creativity, my creative journey, my personal story, part of my crafting world, and they

make my world better. If you were with me in my studio right now, I would talk with you about my work and want to hear about yours, but I would also tell you, with equal excitement and enthusiasm, about theirs. Instructions, details, materials, and directions are important in a handbook, to be sure, but your art, craft, and craftivism begin with the material that makes up your creative core, the inner creative instinct that grounds you in whatever you do. *Your story.* Some contributors to this book are friends and others I admire from a distance, but they all share a love for what matters the most to me. They have found their own particular ways to create beauty in a flawed world. Simply put, they are crafting a better world for themselves and, if we join them, for us as well.

These pages will offer you glimpses into their art, activism, and craft. Some share prescriptive activities and craft-based invitations; others, thoughts on their creativity. My hope is that you are searching for what I was searching for when I found them. Read this book, carry it with you, write in it, pick it up and put it down while going about your life, and explore the extensive careers these contributors have built around their well-crafted lives. You'll be inspired. When I feel lost, I turn to them. They are my favorite playlist, my true north, my balm for the bombastic, and my hope for a better world. Let's go!

✗ ✗ ✗

IN 1970, WHEN I WAS A YEAR OLD, my parents went seeking a better world when they packed up a truck in Vermont with a few essentials: an axe, a bag of grain, rope, a few dishes, some books (my father had been an English major at Dartmouth College), tools, and a

few other basics. The story goes that they drove as far north and west in Canada as they could before settling in a small town of a couple hundred people in the wilderness of Northern British Columbia. They left behind the trappings and luxury of their upbringings—my mother's childhood in Darien, Connecticut, and my father's in Detroit, Michigan—for a life off the grid with actual trapping! The Tahltan people taught them how to fish, set up rabbit traps, hunt moose and bear, use herbs for healing, build a fish house to smoke salmon, build a dogsled, and other survival skills. For seven years we lived without electricity or indoor plumbing. They had come from a world on fire and in turmoil: assassinations, civil rights, the war in Vietnam, the draft. Their form of activism was to craft a new life. They wanted to make something new—making *was* a way of life—and they felt more alive, more engaged, than they ever had before.

This childhood was the only one I knew. As it was, I was. Some might say I was deprived of so many things that I didn't even know existed: neighborhoods, school, television, pavement, movies, etc. I have come to think of it differently: I lived with an abundance of what I knew existed: time with my parents, nature, books, wooden toys, chores, homeschooling, wild animals, a very small community, and tools to make everything we needed to live. I was, without a doubt, in what we would now call a "flow" state 24-7. When I wasn't hauling water from the creek, feeding chickens, working in the garden, playing with old household items (no plastic toys!), pulling my brother around in a wagon, chopping and carrying wood, working on my correspondence lessons (which were then mailed from the small general store three miles away to my teacher in the big city), hanging clothes on a line, beading with my mother, and avoiding bears, I was

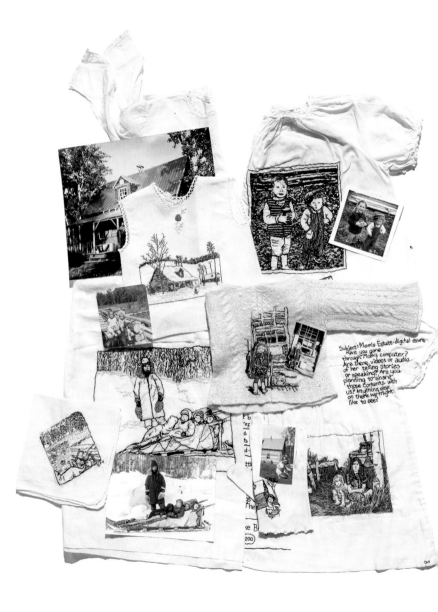

Subject: Mom's Estate - digital assets
Have you gone
through Mom's computer?
Are there videos or audio
of her telling stories
or speaking? Are you
planning to share
those contents with
us? Anything else
on there we might
like to see?

in a world of my own imagination and the natural world around me. I had no limits. I made up an entire world of playmates, dreaming up movies and plays before I knew what they were.

We left the wilderness when I was eight years old. I went to school, discovered television (though *Gilligan's Island* felt familiar to me as they, too, were trying to survive in the "wilderness"), Barbie dolls, friends, and so many other things. Eventually I would go to Princeton University, work in publishing and film in New York City, get married, have four children, travel, and live in a world far from those early years in the wilderness—sometimes as far away from those years as I could go. For decades I did not see the value of my childhood. It was something to chat about at a cocktail party, an interesting story to those who did not live it. It wasn't until I got to my late forties that I began to see it differently. I was in a course called Art and the Language of Craft when I was introduced to the work of the artist Louise Bourgeois. And there it was. It all came flooding back. Something so familiar and so simple: We make. We make by hand. We make in order to process, tell our stories, remember, communicate, heal, grieve, create community, protest, facilitate change, and survive. Crafting connects me to the "unknown known" that nurtured me during those early years of my life and that remains with me. I have come to trust and rely on this feeling when creating my work and to seek it elsewhere in my life.

You'll hear more about my own practice at the end of this handbook, but first, I want to share with you some of the most creative, optimistic people I know, who are called to craft a better world.

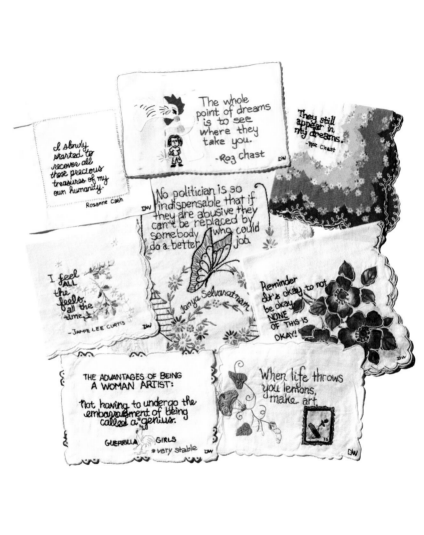

CRAFTING *Life*

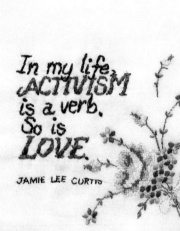

In my life
ACTIVISM
is a verb.
So is
LOVE.

JAMIE LEE CURTIS

A CALL TO ACTION

JAMIE LEE CURTIS

Actor, Activist

When it comes to making the world a better place, Oscar-winning actor Jamie Lee Curtis is prone to action and activism. Whether it's her graphic novel about the climate crisis, Mother Nature, *her books promoting positive thinking habits for children, or her advocacy for pediatric health care, she's a role model and cheerleader for those seeking creative ways to tackle and support big and small causes. She's also very vocal about self-care and a fierce believer in going to bed by nine p.m.! Humble, curious, witty, refreshingly quirky, and authentic all at once, she remains wildly supportive of other people. I once gave her an embroidered piece that heavily featured the word "fuck," and she sent me a personal, handwritten thank-you note that started with "Fuck Yes." There is something infectious about her energetic compassion that reminds me*

that it's best if work is fun, if craft is caring. I encourage you to find people who make you want to jump out of bed and get to work. Jamie Lee Curtis does that for me. Here's her call to action and to saying "yes" to the greatest craft of all: love.

AT THE END OF THE DAY, when we take our last breath, the question should certainly not be about our wealth and privilege and thread counts and fancy things. It should be: "What did we do to help?"

I once spoke at a conference for business leaders and had no idea why I was there, until I realized that that's exactly why I was there . . . to impart that message. We have an opportunity each day to do that. Obviously, everyone has the stresses of life: finances, family issues. When the family has an added complication of a member who expresses their truth and authenticity in a way that is often in conflict with what we had previously thought of them or what society thinks of them, that precious moment offers us an opportunity to rethink and open our minds and our hearts and welcome them. Like the Rumi poem, "The Guest House."

That is my challenge to everyone reading this. In this moment. That's the purpose of the mind. To expand and change and grow. Imagine what it would feel like to be welcomed with warmth and love and acceptance and then to share that with others. There are various ways to share. It can be on a very intimate scale with a few people. Offering yourself to one young person who doesn't have a mentor or a guide can change their life and ultimately could change the world. There are all aspects of volunteerism with institutions who need and want help. For those who have a specific education and/or can expand ideas through action, there are all sorts of positions in electoral politics

and democracies that need good minds, open and willing to serve. You can use the advent of social media. You can write and publish.

I am most challenged by people who opine and use their great intellect to spout opinions and criticisms of others and then do nothing.

In my life, ACTIVISM is a verb. So is LOVE.

—JAMIE LEE CURTIS

THE GUEST HOUSE

This being human is a guest house.
Every morning a new arrival.

A joy, a depression, a meanness,
some momentary awareness comes
as an unexpected visitor.

Welcome and entertain them all!
Even if they're a crowd of sorrows,
who violently sweep your house
empty of its furniture,
still, treat each guest honorably.
He may be clearing you out
for some new delight.

The dark thought, the shame, the malice,
meet them at the door laughing,
and invite them in.

Be grateful for whoever comes,
because each has been sent
as a guide from beyond.

—JALALUDDIN RUMI

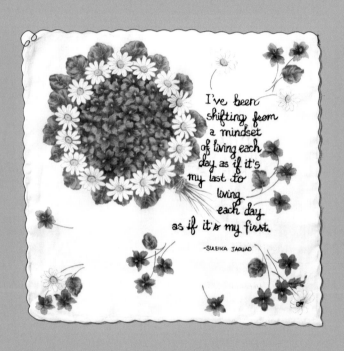

I've been
shifting from
a mindset
of living each
day as if it's
my last to
living
each day
as if it's my first.

-SULEIKA JAOUAD

CRAFTING
CONNECTION

SULEIKA JAOUAD
Author

Suleika Jaouad, author of Between Two Kingdoms: A Memoir of a Life Interrupted, created the Isolation Journals, a virtual journaling community, during the pandemic to help others transform life's interruptions and the unknown into creative material. She is the subject (along with her husband, the award-winningmusician Jon Batiste) of the documentary American Symphony about the healing power of music. Her leukemia returned after a decade of remission, and Jon's musical career exploded. She often writes about making creative company of the contradictions in our lives. I came to know and love her work when, years ago, she gave me permission to stitch her words "You must learn to live on fault lines," and I haven't stopped since! Her wisdom and resilience inspire me, and I now create a weekly piece for the Isolation Journals to highlight their guest contributors and Suleika's writing.

During times of stress, illness, and upheaval, her writing offers insights into ways we might craft a path forward that holds space for the very hard and the very beautiful. Whether she is bedazzling her walker after a chemo treatment or exploring watercolor for the first time from her hospital bed ("Make bad art" is a mantra of hers), Suleika finds comfort in craft. The Isolation Journals, like craftivism, brings people together for an exchange of creative inspirations and work in a quiet, meditative way. So often, we are tempted to retreat into our own worlds of pain, of confusion, or become very distracted by the outside world. I very much wanted Suleika to be part of this book because I've learned so much from her about how to balance my inner life with an outward-facing creative practice. As you will read in her essay, Suleika sees the good work ahead, wherever our hearts may take us, whatever the outcome might be.

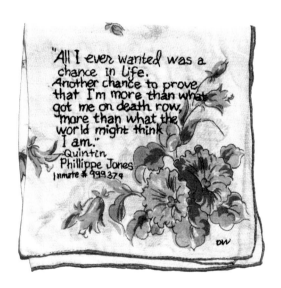

"All I ever wanted was a chance in life. Another chance to prove that I'm more than what got me on death row, more than what the world might think I am."

—Quintin Phillippe Jones
Inmate # 999374

WHEN I WAS TWENTY-TWO, I was diagnosed with an aggressive form of leukemia. My doctors told me that I would need to undergo chemotherapy and a bone marrow transplant, and that I had about a 35 percent chance of long-term survival. Overnight, I lost my job, my apartment, and my independence. I was no longer Suleika. Instead, I became Patient #5624.

When the ceiling caves in on you and your world becomes unrecognizable, it's easy either to cling to what was lost, or to be subsumed by the wreckage. In the beginning, I did one and then the other, which led to great frustration and dissatisfaction, then to despair. But eventually, I learned there is a third way. After such a collapse, there is also a kind of clearing. An opportunity to engage with what has happened, and then to rebuild something new and surprising and beautiful.

My way of engaging with my illness came in a very simple form: journaling. At the suggestion of a friend, my family and I began a hundred-day creativity project. Every day, my mother, who is an artist, painted a ceramic tile that she assembled into a kind of protective talisman she called "Suleika's Shield." My father wrote stories of his childhood in Tunisia. And I returned to a lifelong practice of keeping a journal, which eventually became the grist for my *New York Times* column, "Life Interrupted."

Undertaking this creative practice was powerfully transformative. Not only did writing allow me to gain some measure of control over my circumstances, sharing my story also opened portals into all kinds of worlds, to individuals I never dreamed I'd encounter. One of the very first readers who wrote to me was Quintin Jones, a death-row prisoner in Texas. He'd seen a piece I'd written titled "Incanceration" and felt a resonance in our shared experience of facing mortality and

of isolation—mine in the bubble of a hospital room, his in solitary confinement in a prison cell. "I know that our situations are different, but the threat of death lurks in both of our shadows," he wrote.

Over the next few years, I became one of Quin's many "pen friends," as he called the two dozen or so people around the world with whom he corresponded. He wrote the most wonderful letters, full of curiosity and self-reflection and encouragement. When I finally emerged from treatment, I visited him, and we shared our stories through a plexiglass divider. In most ways, our lives couldn't have been more different—yet we were both eager to find connection. When he asked me what I did during my long hospital stays, I told him that I got really good at Scrabble, and he said, "Me, too!" He went on to tell me about how, even though he spent most of his time in solitary confinement, he and his neighboring prisoners figured out a way to play the game. They made boards out of paper, and they'd call out their moves through their meal slots. I was struck by the tenacity of it—how we learn to adapt, how survival becomes a creative act.

Letters were Quin's favorite thing. After a childhood marked by poverty, abuse, mental illness, addiction, and homelessness, he was incarcerated at the age of nineteen. He had never even left the state of Texas. Writing letters was not only a way of finding companionship, it was also how he traveled, how he learned about the world. It was also an act of self-discovery. In expressing himself through writing, he was able to process his past and what had led him to where he was, whom he wanted to become, and to begin to cross that distance. Letter writing was a path to redemption.

In the winter of 2021, right around the time my memoir *Between Two Kingdoms* came out, I learned that Quin—whom I'd written about in the book—had received an execution date. Immediately I felt

the urgent need for two things. One was to power a clemency plea to convert his death sentence into a life sentence. And as someone who has been faced with my mortality and the terror that goes with it, I wanted him to feel as supported as possible. So I invited readers of my book and also the Isolation Journals, the creative community I had founded to help us stay grounded and inspired during the early days of lockdown, to write to him—to fill his cell with the thing he loved most. And they responded in droves, sending hundreds and hundreds of handwritten letters.

Given the political landscape in Texas, the clemency plea was always a long shot, and it was with great sadness that on May 19, 2021, we learned that Quin's sentence would not be converted from death to life. My husband, Jon, and I spent the hours before his execution on the phone with him. We told stories; we imagined a future that we all knew would never come to pass, where he would come for a visit and we would sit together in my garden and admire the flowers. Jon played the gospel classic "I'll Fly Away," and Quin's favorite by Tupac, "I Ain't Mad at Cha." Quin shared that he had never experienced love before, but in recent months, as he received piles and piles of mail every day from new pen friends, he

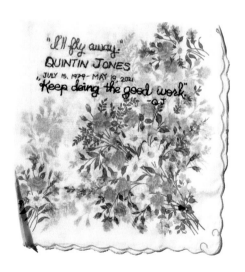

felt more connected to the world and more loved than he had in his whole life. He could go in peace.

The last thing Quin said before his execution was "Keep doing the good work." It was generous of him to leave us with those words. We may not have achieved the outcome we'd hoped, and my heart was broken. It felt akin to an experience I've had many times, befriending a fellow cancer comrade, someone who is facing death, knowing it might break my heart. When that loss came, I knew it was worth it. I feel similarly about this activism work. You know it might break your heart, but it will be worth it. It's a privilege to get your heart broken in that way.

After Quin's execution, I was leaden with sadness, but also something else: a weariness, a marrow-deep fatigue that stretched on for months. The symptoms felt eerily similar to when I first got sick, and an eventual bone marrow biopsy confirmed my worst fear: the leukemia had returned. It was very rare to relapse after almost a decade. It meant that my disease was extremely stubborn, and I thought it was likely I would not survive it this time.

In the weeks that followed, I thought of Quin. He had endured extraordinarily isolated, impossible circumstances; for more than twenty years—more than half his life—he lived in a literal cage, in solitary confinement for twenty-three hours a day, staring his own mortality in the face. When I visited him, he had told me that he initially coped by drinking homemade prison hooch. He wanted to drown out the pain, drown out the fear. But eventually he realized that behavior wasn't serving him, and instead of numbing himself, he began reaching out to the larger world in curiosity. In his letters, Quin asked so many questions. He wanted to know everything from what my favorite color was to what I was planting in my garden, to the things I

was seeing and the people I was meeting. There was a palpable sense of exuberance and childlike wonder.

When you're faced with a serious illness, there's a lot of talk about living each day like it's your last. That may work for some people, but as someone who will be in cancer treatment for the rest of my life—who will never be considered "cured"—it adds a level of pressure that just isn't sustainable. (I suspect that if we actually followed that dictum, we'd all be running around cheating on our partners and robbing banks.) So instead, as I navigate this new phase of ongoing illness, I've shifted from a mindset of living each day as if it's my last to living each day as if it's my first. Especially when the temptation is to be jaded and world-weary, I try to look at everything around me with fresh eyes, like a newborn might, to seek out and hold on to wonder.

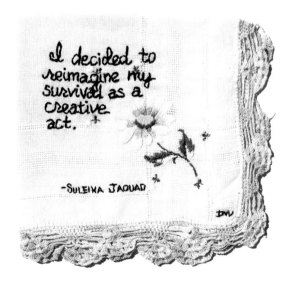

I decided to reimagine my survival as a creative act.

—Suleika Jaouad

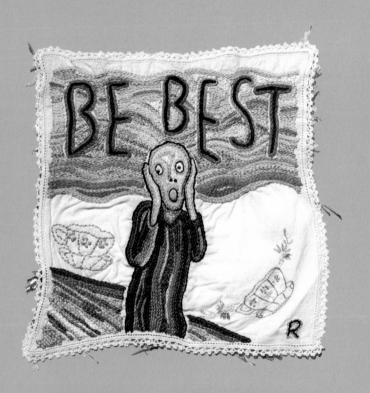

CRAFTING

ANXIETY INTO ART

AN INTERVIEW WITH ROZ CHAST

Cartoonist

Roz Chast is a staff cartoonist for The New Yorker and has written nine books, crafted hundreds of cartoons, painted pysanky eggs, and embroidered small, vivid tapestries. Her work speaks to the angst of being beautifully odd, having a compulsion to imagine inanimate objects as full of life, and finding humor at the frayed edge of anxiety.

I first met Roz in person in a diner on Manhattan's Upper West Side. (As I write this, I cannot help but hear Neil Young's "Unknown Legend" and imagine Roz on a desert highway on a Harley-Davidson. That's the kind of flight of imagination she inspires!) In a booth with a yellow Formica tabletop, Roz gave me the piece she had embroidered for Tiny Pricks Project. She had stitched the words "BE BEST" (a nod to former first lady Melania Trump's public-awareness campaign against bullying) above an apocalyptic rendering of Munch's The Scream.

When I am confronted with the complexity of the world, the vast scope of what it means to be alive today or any day, it is a gift to hear her voice crying out in the urban wilderness. She is able to articulate and make art out of our deepest and our most banal anxieties equally. It's all material! Roz's work seems to suggest that if we add comic captioning, thought bubbles, and cartoons to our lives, we might find it a little easier to get through both daily tasks and the profoundly difficult.

I interviewed Roz by email just as her book I Must Be Dreaming *came out. I started by sharing my dream of her on a motorcycle because, when you're with Roz, you're never as free as when you're imagining a world in which anything can happen.*

ROZ: The image of me on a motorcycle makes me laugh. I don't even like bicycles. Also: deserts and highways: no and no.

DIANA: I'm thinking of calling this section "Profiles in Creativity" in honor of John F. Kennedy's *Profiles in Courage* because I think it's brave to be an artist. Some people think that people are just born artists so they are actually people without other choices. I think it takes courage to be an artist. Do you think you were destined to be an artist or do you think you made yourself an artist? Was/is there anything else you could imagine being? Could still be? (Go wild.)

ROZ: I don't think being an artist is brave, unless you're talking about making a living. It's an extremely precarious profession, which gets more precarious every year. Firefighters are brave. Rejection sucks and hurts, but you're not going to die. The only thing I ever liked to do, or could do when I was a kid, was draw. I was very, very pulled toward that. I wasn't social, I hated sports, I loved to read but didn't like school. When I was thirteen, I started drawing cartoons. I liked the way they

combined drawing, writing, and humor. I can't remember a time when I didn't want to be an artist.

DIANA: I feel sometimes when we talk or email that every subject could be a rabbit hole that we could tumble down into, but that we're really always circling around two questions: what can we make and how can we make it? Do you ever feel like there is always a long queue of ideas waiting for you to call their number (or to take off on the runway), or do you feel like your creativity is like a pair of glasses that you can take on and off?

ROZ: I definitely am always thinking about making stuff. There's always a queue of mediums I want to do or try, artists I need to look at, books that might be fun to make . . .

DIANA: If you formed a CA (Crafter's Anonymous) group, what would be some of the steps for recovery?

ROZ: Definitely no more trips to Michaels. Also: you're not allowed to go on the Blick website and order various things because you've been looking at a lot of, say, block printing online and suddenly there is a need to get into block printing. Then you read that Pfeil carving tools are way superior to the cheapo Speedball ones. And since you've already done a little carving in your day, you know that Speedball tools are okay, but not great. They leave these little scraps and tabs and doodads, which are annoying. And the Pfeil carving tools cost like $200 compared to like $20. But isn't that what money is for??!!???? These are the kinds of things that will be forbidden.

DIANA: I really like that you used the word "forbidden" because that introduces an element of strict measures, Garden of Eden–style. The forbidden fruit. What if the Serpent had offered Eve a ball of yarn? Would she have knit matching wool underwear for Adam and herself? What is your most "forbidden" craft?

ROZ: Whatever craft I'm doing, in a way, is the most forbidden. Because I get so wrapped up in it, it becomes all I want to do. I want to throw everything else out the window: grocery shopping, laundry, friends, work deadlines, emails that must be answered . . . To hell with everything except the thing I'm working on. I get obsessed.

DIANA: When you use words like "Howzabout" (as you did recently in an email), I immediately "see" the word as a graphic. I am not reading it exactly. This gets me into trouble when I am stitching—I make "stitchos" and have to take out the stitches to correct my mistakes. (I dream of autocorrect for stitching.) Do you see words? Do you have some favorite words? Least favorite? Banned words?

ROZ: I love stitchos! Like typos! So great. Hateful words: I have quite a few words I dislike intensely. I hate "wellness." Also "journey," unless it's used to describe anything other than actual travel, and even that . . . don't like it. Just say "trip." And "wellness journey" is loathsome. I hate that so much. Also "sammies" for sandwiches. And "veggies." Baby talk, yuck. Also hate when something like chocolate cake is referred to as "decadent." No. Buying a $150,000 handbag is decadent.

DIANA: There are some things I find very confusing, and it's a small miracle to me that they exist. I find myself creating narratives for them so that they make more sense. I feel like this might happen to you. And what is up with crocheted hangers?!

ROZ: Crocheted hangers?!?!?!? That is a craft too far.

DIANA: You had already made a name for yourself when social media arrived on the scene. How has social media changed your practice? Do you embrace it or socially distance yourself from it?

ROZ: I like Instagram. It's visual. I like looking at art and at crafts people do. It can be a very inspiring source of images. Twitter and Facebook— not for me.

DIANA: One of my favorite covers of yours is *The Party, After You Left.* Your cartoons are like tiny time capsules. (I actually remember when everyone hoped Benicio del Toro would show up at a party in SoHo in the '90s.) Who's at the party now if you updated it?

ROZ: Are there still parties?

DIANA: If your parents considered spiritual questions "navel gazing," what did they think about art?

ROZ: My parents loved music. They had a subscription to the Metropolitan Opera. They went to many concerts—classical music. But the visual arts did not interest them. They subscribed to *The New Yorker* and they were proud of me, although I don't think they "got" my kind of jokes.

DIANA: We've seen what the "to-do" list of your childhood and adolescent world looks like in *Can't We Talk About Something More Pleasant?* I guess "Do not die" just stays on the list. Maybe it moves up? How would you update that list now?

ROZ: Do not die remains important.

DIANA: I remember this moment in high school when I was complaining to my mother about something and it was finally getting to her. "I never promised you a rock garden!" she shouted at me. I loved that then and I love it now. 40+ years later, I had to stitch that. Do you think remembering and making art about moments like this with our parents can keep them around longer in our memories?

ROZ: I love that!!!!! Of course you had to stitch it. And absolutely YES, times infinity, to your question. I wrote about my parents to remember them. I did not want to write a bullshit Hallmark card version of what they were like. I wanted to really, really remember them: how they spoke, what they said, what they fought about, how they dressed, how they stood, how they SAT ON A CHAIR.

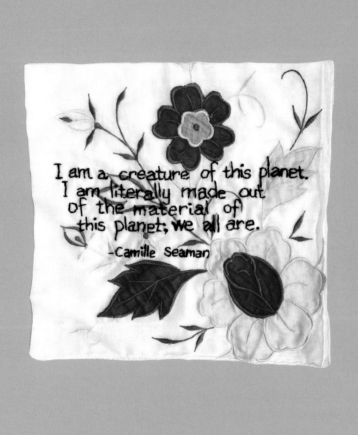

I am a creature of this planet.
I am literally made out
of the material of
this planet; we all are.

-Camille Seaman

THE CRAFT OF CAPTURING
CLIMATE
AT SEA

THE WORK OF CAMILLE SEAMAN
Activist Photographer

Camille Seaman is a photographer who is of Native American and African American descent, a TED Senior Fellow, Stanford Knight Fellow, National Geographic Contributing Photographer, and the author of The Last Iceberg *and* Melting Away: A Ten-Year Journey Through Our Endangered Polar Regions. *She photographs endangered icebergs using the principles of portraiture and talks about them in poetic terms like "ice shelves," "Tabular icebergs," "fractured," and "calving." Her work closes the existential and literal distance between humans and nature. Because her sense of well-being comes from her surroundings, Camille*

goes to the wilderness of deep water to feel relaxed and grounded. She captures her transcendent encounters with a world melting away so that we can connect with this part of ourselves. In 2016, she joined and photographed the historic gathering of tribes at Standing Rock Reservation in North Dakota to protest the Dakota Access Pipeline. She has also made fully hand-beaded moccasins using traditionally brain-tanned smoked deerskin, vegetable-tanned cowhide soles, vintage Venetian glass seed beads, dyed horsetail, and tin cones. Camille recalls her grandfather saying to her before he died, "You are a survivor of slavery, disease, and genocide. You carry the strength of all your ancestors inside of you, and you can access it at any time. You are born of this time, for this time, and there is no one like you." She is of this time on earth, and if we listen to her, we can join her ancestors to help save it just in time.

Here is Camille's take on the world and the need for art, as heard on PBS NewsHour's "Brief but Spectacular."

ART IS NOT ONLY IMPORTANT. It is necessary for us to communicate what is happening with our planet. Without art, I don't think we will ever truly be able to communicate what climate change is.

I had an incredible childhood. Primarily, I spent time at my grandparents' house. And my grandparents are of Shinnecock and Montaukett descent. And my grandfather especially thought it was very important for us to know that we were interconnected and interrelated with all beings.

As a small child, he would take me into the woods and introduce me to each tree. And he said: "This is your relative, in the same way that I am your relative. And you must respect it."

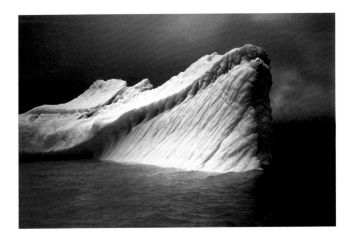

When I saw my very first iceberg in Antarctica in 2004, I remember just shaking, because I was thinking, how many snowflakes is this? How many ancestors' water is this? And so, when I photographed them, I am literally photographing the water of my ancestors, as if I am making a portrait of my ancestors.

I feel that a photograph is not successful if it's only giving you information, without helping you to feel something. If you look at one of my photographs and feel nothing, I have failed. I look at the glaciers that I have photographed, for example, in Antarctica. And those glaciers look crumbly, unwell, unsafe.

The climate change that I have witnessed in my now twenty years of visiting the polar regions is shocking. I hope that humans will realize that we are of this Earth. We only get this one. And, one day, we will realize just how special it is.

I just hope it's not after we have lost so much of what makes it special.

June 14, 2015

Dear Maira Kalman,

Would you join me in
exhibiting textile and
text at the Arts Council
of Princeton in Princeton, NJ
in January?

Yours in stitches,
Diana.

DW

CRAFTING A

"LIFE-IS-GOOD"
COLUMN

AN INTERVIEW WITH MAIRA KALMAN
Artist, Illustrator, Writer, Designer

*Maira Kalman is an artist, author, illustrator, and designer who has
written many books for adults and children, but writes to the adult in
every child and to the child in every adult. She also creates illustrated
versions of books that interest and amuse her:* The Elements of
Style, Michael Pollan's Food Rules: An Eater's Manual, *and* The
Autobiography of Alice B. Toklas, *to name a few. She also made a
video of herself dressed up as Alice B. Toklas exploring her New York City
neighborhood, even buying and eating a street hot dog! After being a
fan of her art and books for years, I discovered that she also embroiders.
Maira's embroidery is very much like her writing and art: easy to
recognize stylistically but magically unpredictable. She smooths the rough
edges of the heart. In 2015 I emailed her to ask if she would be part of*

Every Fiber of My Being, a textile-based group show I was curating for the Arts Council of Princeton. I found her work email address online, composed a message outlining the show, asked if she would exhibit some of her embroidery work, and sent it into the great unknown with a short prayer. No response.

A couple of weeks later I was running when I had a mini epiphany: I would stitch an invitation to Maira! If that didn't elicit a response, it wasn't meant to be. I ran home quickly, stitched an invitation, took a photo of it, and sent it to the same email address. Maira soon sent an enthusiastic reply with contact information for her gallerist, and her work was eventually in the show! I felt like I had won the lottery. (In my world, I had!) A couple of years later, I even joined Maira and her sewing circle for a session in her apartment. Sitting together, needles flying, thread and yarn unspooling, I was reminded once again of the way in which a craft serves as a communal language.

One of the reasons I am so drawn to Maira's work and want to share it with you is that she is always searching for ways to connect through her craft. She has created a series of tiny gift books and packages of poetic offerings: "still life with remorse booklet, pouch, poster" and "don't think too much." She keeps what she calls a "life-is-good" column in her mind. She often encourages us to hold on to the bittersweetness of things that matter the most to us and, if that doesn't work, at least find a good hat or cake to draw. Maira's tools in this battle are curiosity, work, love, joy, art, and respect for profound loss.

Thankfully I didn't have to stitch my questions for the following interview with Maira!

DIANA: Would you call your embroidery "freehand," and what does that term mean to you?

MAIRA: Most definitely freehand. Approaching with a kind of freedom and looseness. To show the mistakes and inconsistencies.

DIANA: I like the busywork of stitching. It reminds me of other kinds of work: making a bed, doing the dishes, and dusting. Quick, reliable, and predictable results! What do you specifically like about embroidery, and when did you first pick up the needle?

MAIRA: Embroidery was something that all the women in the family did. Tablecloths. Pillowcases. Nightshirts. It is part Belarus. Part Shaker. That feeling that there is always something interesting to do. The beautiful colors on the beautiful linen. Then the brain is free to roam and wander. Think and not think.

DIANA: My first deep dive into embroidery was to stitch photos from my childhood in the wilderness onto textiles that belonged to my mother's family. They were really textiles from another era and lifestyle (all that ironing!!). I couldn't imagine using them in a practical way. I couldn't imagine throwing them away because they came from my family. I wanted to preserve them in an interesting way. Do you keep family artifacts for your work? Do you use photos for inspiration for embroidery, and how do you select your textiles?

MAIRA: I often work from photos. Taking pieces from different places. I have a massive number of linens from all around the world. From hotels. Flea markets. Family. And somehow, I find the right cloth.

DIANA: I sometimes get a little worked up by the "embroidery as art" attitude (to me it's like saying "literature as literature") that people have about this medium. Do you think of embroidery as being different in a significant way from the other mediums you work in? Isn't it art?

MAIRA: It is certainly art. The idea that women's work is craft is very ingrained. But so many have taken it to another level.

DIANA: In 2016, you loaned your series "Goethe: An Embroidery in 4 Parts: I feel a sense of dread; My big rigid heart; What I possess; and What had disappeared" to the Arts Council of Princeton for the *Every Fiber of My Being* show I curated. Can you share a little bit about this beautiful series?

MAIRA: The pieces were done when my mother died. Her loss created a void of unimaginable proportions. The Goethe quote embodied how I felt.

DIANA: We stitched together with some of your friends in the fall of 2019 in your apartment in New York. You were working on a dress. (Did you finish it?) Some were knitting, others were embroidering. As I was leaving, you gave me chocolates and an orange for my NJ Transit trip home. (I think I accidentally left a pair of embroidery scissors in the folds of your couch as I was packing and was later afraid you might sit on them!) It was a perfect day, I thought, while I alternated between eating pieces of chocolate and eating slices of orange on the train. Do you ever have that feeling that it is all too wonderful, too much, and that the next minute it will be otherwise? Do you feel that stitching can capture some of this delicate magic?

MAIRA: Everything changes all day long. The strands of sadness and joy are always present. And I don't think I ever found your scissors. But sorry if I have them and didn't return them!

DIANA: When my father passed, we went through his things too quickly. (I don't know why. Maybe to make it all more real?) I wish I still had his shirts. I am so glad that you kept your mother's things. (Look at how much material came out of her closet!) How did you know to keep it, or was it not a "knowing" so much as a yearning? Or just saving?

MAIRA: There was no thinking involved. I just felt that her closet was a work of art and that we had to keep everything. I often think

that the thing you blurt out without thinking is the most important information you have. Listen to it.

DIANA: This book is in part about the connection between art and activism. I was thinking about the small books you created during the pandemic as quiet activism. Sales of some of the small books and trays benefited No Kid Hungry, UNICEF, and Action Against Hunger. (I wish there were more of the "coziette + tray: the marcel proust" trays.) I visited you in 2020 on a day when your apartment was turned into a production line of painted trays, linens embroidered in India (you were excited about that discovery!), and tissue-paper packaging. The trays really made me want to sit and have a cup of tea! What inspired you to make them and how was it making them?

MAIRA: Everyone needs a tray. And a constant connection with literature (in this case Marcel Proust and Walter Benjamin) is lifesaving. I mean that literature is literally lifesaving. So tea and cake and books on a tray to bed. What more do you need?

DIANA: You said on the *On Being* podcast that your "heart goes out to everybody." I really feel that when I read your books. The sad is made happy, the happy is made bittersweet. Does art give you comfort? Not too much joy, not too much sadness?

MAIRA: Art is my solace. My work.

DIANA: I thought about you from time to time during the pandemic because I feel like you have found ways to keep yourself going. Like walking. Good habits! Any new ones that you've discovered more recently?

MAIRA: Just more of the same. More walking. More reading. More listening to music. More early to bed. More pleasant solitude. More family connections. More work with my son, Alex.

POSTER
GIRLS

GUERRILLA ACTIVISM AND ART

THE GUERRILLA GIRLS

Activists

*The Guerrilla Girls is an anonymous feminist collective formed in
1985 that challenges issues that plague the art world: lack of equal
representation in museums, male-focused history of art, unequal access,
internalized bias, lack of diversity, institutional income inequality,
tokenism, and unethical museum funding practices. Members use
disruptive, fun, catchy, visceral, grassroots interventions to make
headlines, create daring visuals, and share statistics exposing gender and
ethnic bias in the world. They generally craft their interventions by using
preexisting information and readily available academic research, bringing
it to the street with posters, billboards, and public demonstrations.*

Working literally under the dark of night and with hidden identities, they have used their celebrity to keep the focus on issues, not individuals. The updated Guerrilla Girls' Art Museum Activity Book *has some crafty ideas that never, unfortunately, get old: count the number of female versus male artists or nudes on the walls, correct wall labels using feminist language, distribute creative protest flyers in reclaimed spaces like bathrooms, and dress up like a docent to give an alternative tour. Get active in art spaces! Ask yourself crafty questions: Who pays for this? What is the story behind what's on the walls? Who is missing from this conversation?*

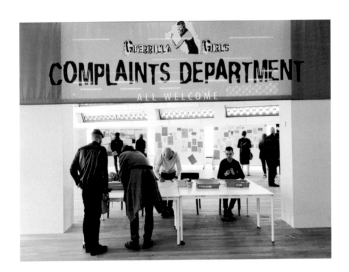

GET OUT THERE AND DO ONE THING. If it works, do another. If it doesn't, do another anyway. Just keep chipping away. We promise that, bit by bit, your efforts will add up to effective change. We are also big on complaining, as "Complaining is an important aspect to Change." Our "Guerrilla Girls Complaints Departments" have been installed around the world, inviting people to write their complaints on large chalkboards or Post-it walls.

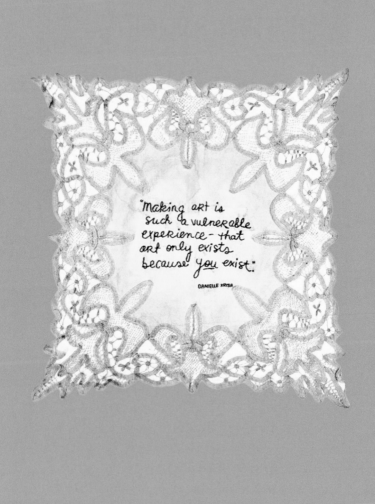

"making art is such a vulnerable experience - that art only exists because you exist."

DANIELLE KRYSA

STITCHING
OUT OF
DARKNESS

RACHELLE HRUSKA MACPHERSON
Founder of Clothing Brand Lingua Franca

Rachelle is one of the reasons you're holding this book in your hands today, as she helped me grow Tiny Pricks Project *in a meaningful way. We caught each other at a special moment in time. She had created cashmere sweaters stitched with the slogan "I Miss Barack" while working herself out of postpartum depression. She was also breaking into the activism and fashion worlds. I had just started* Tiny Pricks Project, *and I didn't have an audience on social media. I had made most of the six hundred pieces in the collection myself, and I was just starting to look for exhibition spaces.*

In the spring of 2019, I packed all the textile pieces into a suitcase and flew to New York City to meet Rachelle for the first time. During our meeting at Lingua Franca's office workshop in the basement of the Jane Hotel, I was immediately charmed by Rachelle's personal brand of fierce

enthusiasm, infectious curiosity, uncanny business sense, and no-holds-barred activism. When it comes to making an impact on the world, finding kindred spirits to get into good trouble with is key. Sometimes other people can pick up your work and take it to places you never imagined.

At that time, many people were tiptoeing around Trump's language and afraid of offending people, but Rachelle wasn't. She knew how she felt. If she lost Trump supporters as clients, she was fine with that. During our first meeting, she offered things that sounded too good to be true: an exhibit in their store on Bleecker Street, a publicist to help get the word out, a project T-shirt made out of recycled bottles, sewing circles, a "bigly" opening, national press coverage, a design team, and an exhibition catalog. About a month later, at the Tiny Pricks Project opening, the Resistance Revival Chorus (RRC), dressed in all white, came up from the store basement, singing through the gallery and out onto Bleecker Street. A crowd gathered around the storefront to watch and join these beautiful, amazing women as they sang joyous protest songs. The RRC had been, of course, Rachelle's idea. After they sang, I found Rachelle and gushed about how wonderful they had been. "Yes!" she agreed, but then continued. "Did you see that van? I should have blocked off the parking spots in front of the store." I had not, of course, noticed the van, but Rachelle had, because it was a hindrance to the crowd forming a proper half circle around the choir to join them. This, I was to learn, was the way Rachelle's mind worked: the creative process is expansive and extends to all the elements that make up an event, a protest, and an art movement. You anticipate the obtrusive parked van. You consider the small and large details that have to come together, and you breathe life into it all as if it were inevitable, the edges of hard work rubbed smooth with grace and joy.

One of the many wonderful things about the Lingua Franca exhibit in the West Village was that June 28, 2019, was the fiftieth anniversary of the Stonewall Uprising, and the Stonewall bar is just around the corner from Lingua Franca. Locals from that era came into the store again and again to look at the pieces pinned to the walls. One of them said to me, "This is the most honest thing I have seen in the Village in years." Lingua Franca became my home that summer. The New Yorker *and others published pieces about it, and next thing I knew, people from around the world had helped the project surpass its goal of having 2020 pieces before 2020.*

I STITCHED MY FIRST SWEATER in darkness. Not literal darkness of course, I wouldn't recommend that. No, I was in a gnarly postpartum glum and was instructed by a well-meaning therapist to "find something to do with my hands." Me?! A Manhattan-dwelling, new media entrepreneur at the time. Me?! You want me to command my little twenty-first-century phalanges to make you something creative?!

A couple of days later, while driving out to Montauk on the Long Island Expressway on a cold February evening, we passed a Joann Fabric and Crafts, and it hit me—I did know how to make something with my own two hands! Pull over!

The request was so bizarre and out of nowhere, that my husband, Sean, just pulled right over, no questions asked. And with my two babies screeching in the back seat, I hurried in and knew exactly what to do. My grandma Rita had taught me how to embroider as a young girl on her farm in Ulysses, Nebraska, and I had been to these kinds of

stores before. Looking back, I really do think she herself guided that chaotic car into that giant commercial lot that night.

I started plotting like a madwoman in Joann while my husband and babies waited for me in the car. When we arrived in Montauk, I picked up an old cashmere sweater (left behind by my mother-in-law and soon-to-be-muse, Janet MacPherson, who surfs in them!) and embroidered a janky "booyah" on it in bright red thread. I stitched it in the only style I remembered how to do—a stem stitch, which, in hindsight, was not an ideal one for using on letters. But hey! It was also what made it look so unique. I posted the finished project on Instagram, happy that I did my "homework," and totally unaware of the wild ride it was about to birth.

Embroidery on sweaters wasn't a cure-all for my extreme anxiety and depression—that's something that's a constant work in progress. It *did* give me a purpose, which, shocker, is sort of a big help for depression and anxiety. It also grew into something that I could never have imagined.

Lingua Franca, at first, connected me to a vast and beautiful network of other textile creators and then, later, when I started stitching political and social justice phrases, to a world that I never even knew I belonged in—the world of fashion, the world of activism, the world of "giving a damn," which became our motto. I had found what made my soul sing.

I love this line I once read: "The gift is in the wound." It's certainly been the case for me in this journey of building Lingua Franca—which means a "common language"—alongside so many incredible humans.

My advice: Don't wait! Pick up a needle, a pen, a piece of paper, pull over, and start making! Or just stand up, take a deep breath, and let loose—sing, dance, love, create! The world can be a depressing

place. Find the beauty and don't think twice. Listen to those chaotic and bizarre voices in your head and run like wild toward them. I truly believe that one of the greatest forms of activism is making your own world beautiful. This concept, of making, not taking, the beauty in our world was top of mind for me during the beginning of this wonderful and weird journey of Lingua Franca. It is still at the heart of every SKU (fashion speak for each "piece") we make, every collaboration we start, and every person we partner with.

Luckily for me, Diana gets it. She runs toward the magic. And we ran like madwomen together on this very special project. It was a peaceful, beautiful, collaborative form of resistance that was more powerful than I ever could have imagined. What a gift out of darkness we created together!

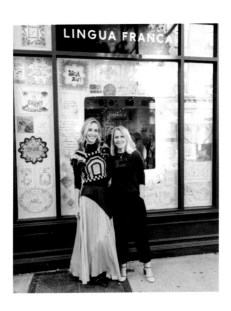

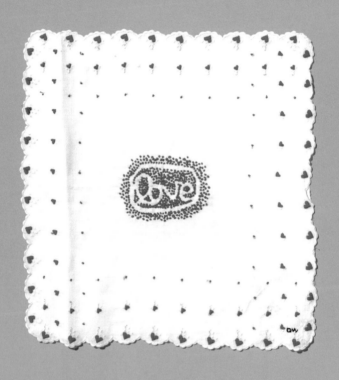

CRAFTING

LOVE

ALEXANDRA GRANT
Founder of grantLOVE Art Nonprofit, Cofounder of LOVE Cookie Craft

VICTORIA KNIGHT
Chef, Cofounder of LOVE Cookie Craft

grantLOVE is an art project founded by Los Angeles–based artist Alexandra Grant in 2008 to raise awareness and funding for arts nonprofits by gifting and selling her LOVE design and art. Her LOVE symbol is used in collaborations to spark meaningful conversations, share stories of resilience, and empower activism through the practice of encouraging a more empathetic world. grantLOVE collaborations have produced art, jewelry, home goods, neon signs, clothing, prints, other expressions, and murals. They recently partnered with Fred Segal to support arts education and youth experiencing homelessness. grantLOVE supports collaborating artists directly through stipends, materials, and help with production costs. So many artists want to work on making the world a better place, but this comes at a personal cost to them.

The scope and diversity of their work is a good reminder to consider economic realities, small-business logistics, and funding mechanisms as we seek the most effective ways to leverage our love in the name of activism. I'm excited to share this cookie recipe from Victoria Knight's collaboration with grantLOVE so that you might share a little sweetness at your next sewing circle, family gathering, or political event.

GRANTLOVE PROJECT, which I founded in 2008, is an experiment in alternative philanthropy. The initial impetus and goal of the project was to produce editions and artworks that could be used as donations to help raise funds for nonprofit organizations. The LOVE symbol is the marker of this project, and over time, it's become clear that this symbol has power in infinite applications. It's a reminder, a visual tool that can be employed to counter negativity and hate and to spread LOVE. This recipe, originally created by chef Victoria Knight for *LOVE: A Visual History of the grantLOVE Project*, is just one example of how this symbol can be used. Spread the LOVE to your neighbors, friends, family, and strangers!

LOVE COOKIE RECIPE

BY VICTORIA KNIGHT

Makes 16 cookies

INGREDIENTS

1½ cups (170 g) ground almonds/almond flour

1½ cups (160 g) all-purpose gluten-free flour

Pinch of salt

½ cup (100 g) unsalted butter, melted

6 tablespoons maple syrup

2 teaspoons of vanilla paste

Optional: melted chocolate, chopped pistachios

DIRECTIONS

1. Preheat oven to 350°F and line two large baking sheets with parchment paper.
2. In a large bowl, add the almond and gluten-free flours and the salt.
3. Next add the butter, maple syrup, and vanilla and mix to form a stiff dough.
4. Turn the dough out onto a sheet of parchment and shape into a long roll. We have made ours rectangular, but you could do a cylinder or any shape you like. Wrap up in the parchment paper and refrigerate until hard. The mix will keep in the fridge for a week or two and longer in the freezer.
5. When the dough is set, slice into ⅓-inch (1-cm) thick cookies and place on the prepared baking sheets. Bake in the oven for 15 minutes and leave to cool before decorating.
6. Decorate with the LOVE symbol—we have dipped our cookies in melted chocolate, but get creative and decorate however you'd like. Chopped pistachios work well sprinkled onto the melted chocolate!

What Do You Regret?

When Was a Time You Led With Your
 Heart?

What Makes You Happy?

What Was Your Biggest Failure?

What Got You Through Your Greatest
 Challenge?

What Is a Good Person?

What Is Love?

Have You Ever Cut Someone Out of
 Your Life?

How Do You Want to Be Remembered?

What Is Good Advice?

What Will Your Epitaph Say?

What Will Your Final Blessing Be?

 Steve Leder

ESSENTIAL
QUESTIONS

STEVE LEDER
Senior Rabbi of Wilshire Boulevard Temple in Los Angeles

Are we living our truth, or are we just talking about our truth?
—STEVE LEDER

Steve Leder is the Senior Rabbi of Wilshire Boulevard Temple in Los Angeles, a scholar, a Jewish community leader, and the author of five books, including More Beautiful Than Before *and* How Suffering Transforms Us. *While my hands are busy through the busywork phase of a craft project, it can be a time to replenish, repair, renourish, rage (gently), rest, and rework. I love John McPhee's phrase, "knitting away at the words," when talking about working on a draft for a writing piece. Some like to zone out while crafting (binge craft!), and, as you might have guessed, others like me see it as an opportunity to knit away at some existential questions and reflect on best practices in general. Podcasts are*

a favorite medium of mine for information, inspiration, and reflection. I find them more intimate than videos, for some reason. It was on the Everything Happens with Kate Bowler *podcast's "Don't Come Out Empty Handed" episode that I was introduced to Rabbi Steve Leder. I started to take so many notes while listening that I had to read the transcript later as well! Over two years of stitching Trump tweets had left me with a deep craving for wisdom, intelligence, beauty, kindness, and sanity. I needed something to rebalance me, redecorate my mind space, after "drinking out of a fire hose" of toxic language. While I know that activism is fueled by a sense of wanting—needing—change and being prone to action, it is also helpful to root it in stillness. Steve's work gives me food for good thought. Whatever your practice to replenish is, I hope it goes hand in hand with your output.*

In his book For You When I Am Gone, *Steve Leder offers twelve questions with which we can explore how we want to live and what we want to leave behind when we die. He encourages us to write ethical wills: What values of ours will emotionally and spiritually nourish our loved ones when we are gone? For me, art asks some of the same questions. What can we say about ourselves and our lives in our art? About what is most important to us? Consider his twelve questions on the previous page—meditate on them, journal about them, talk about them. Let these questions be a wake-up call: how do you want to live? And once you know how you want to live, how can you make a difference in your own life and the lives of others?*

PROPAGATION PRACTICE

TANYA SELVARATNAM
Artist, Author, Producer

Tanya Selvaratnam is a writer, film producer, activist, and actor. She is the author of The Big Lie: Motherhood, Feminism, and the Reality of the Biological Clock *and* Assume Nothing: A Story of Intimate Violence. *A firm believer that art has the power to create community around multiple perspectives, Tanya has said that she writes her way out of the darkness. When I heard that Tanya was writing about finding meaning in the company of plants during the pandemic, I wanted to hear more about her new craft. We had collaborated on pieces when* Assume Nothing *came out, to raise awareness about domestic abuse and intimate partner violence. Her plant practice is another tool that we can take into our own homes: helping, watching, and supporting something that is growing under our care as we nurture our inner landscapes and practice self-care.*

FOR MOST OF MY ADULT LIFE, I wasn't able to have houseplants. From my base in New York City, I traveled too much for work. Around the holidays in 2020, in the depths of the pandemic, a friend sent me a plant, a holiday cactus. Because I knew I would be home for the foreseeable future, I felt that I could take care of it. But the cactus seemed lonely, so I decided to get it a companion. I looked into plants that could grow in low-light environments. I landed on a ZZ plant. As the shopkeeper told me, "It can grow in a closet." I put it in my living room.

The ZZ originated in eastern Africa. It is otherwise known as "Zanzibar gem" and "eternity plant." I was thrilled to watch six new shoots of a bright green hue rise and then tower over the original, darker green shoots. I bought two more ZZs, one for my office and the other for my bedroom.

I was having a late-blooming love affair with houseplants. I was becoming a plant lady. I bought a planter in the form of a unicorn and picked a succulent with one stalk and a spiky pink crown to go inside. The succulent looked like the vibrator I had bought during the pandemic but didn't use after an initial tryout. I found the thought of the vibrator more stimulating than the feel of it. But the sight of the succulent's spiky crown filled me with bliss.

Soon after I purchased the succulent in the unicorn planter, I wanted an animal companion for it. I bought an elephant planter, and the shopkeeper helped me pick a philodendron. Translated from Greek, its name means "love tree." The heart-shaped leaves seemed to tickle the elephant as they grew higher and flopped around its ears. I spoke to the unicorn and the elephant, and they seemed to hear me. The plants inside them fluttered ever so slightly as I stood still beside them.

The plants kept me company as I prepared myself for the release of my second book, *Assume Nothing: A Story of Intimate Violence*, in late February. Because of its subject matter—my trajectory from witnessing as a child domestic violence between my parents to then experiencing domestic violence as an adult myself—I knew that I would be exposed publicly in ways that would be painful and uncomfortable. So I tried to focus on the intention that the book would help others spot, stop, and prevent intimate violence. The plants brought me intimate pleasure to counter my story. I emerged from writing the book feeling stronger than before, but talking about it over and over again to the press sunk me into a depression. I was partially humiliated by what had happened to me.

I will try to put into words my depression: I didn't want to wake up, and I didn't want to go to sleep. During the hours in between, I felt pain acutely in my gut. It was a sinking feeling. It was a caving-in feeling. It felt as though my heart were burning down. It felt like hopelessness. Negative thoughts spiraled in a seemingly infinite loop. I did not want my torpor to end. I struggled and asked myself, "What do I do when many people want to see me but I want to see almost no one?"

The comfort I derived from the plants made up for the discomfort I felt around people.

My greatest fear as an artist is that no one will see my work. In the depths of my depression, I worried that no one would buy my book. The plants brought me solace. A plant does not care if I'm a bestseller or not. The plants also helped me understand that just as I couldn't know which way they would grow, I couldn't know which way my book's life would emerge.

WHEN THINGS FALL APART WE SING

AFRO-INDIGENOUS ECOTHERAPY PRACTICES FOR WELLNESS

J. PHOENIX SMITH

Ecotherapist

Growing up in the wilderness gave me a sense of how to be alone in the natural world. When I read about J. Phoenix Smith's nature-based exercises to address mental and physical health, I recognized their commonality with craft-based practices. Getting in touch with our natural selves brings us back to our bodies, breath, and intuition. When I'm not grounded in the natural world, I find it harder to navigate current political discourse. During the pandemic, like so many others I took up the life-changing practice of cold water dipping. Water is often used as a metaphor for the undercurrents of our emotional lives. Things get very real and very quiet when you're standing in a freezing-cold ocean as the

sun rises on the seemingly endless horizon. I hope Smith's sharing will inspire you to repair and restore your creativity by engaging with nature. Our destiny is forever dependent on the natural world. The more we connect with it, the more likely we are to find solutions to the climate crisis.

IN THE AFRO-INDIGENOUS SPIRITUAL LINEAGES that I was initiated into, we are taught over and over about the need to have and gain inner strength as an important character trait. The Elders have been saying year after year that as humans continue to destroy the Earth and her ecosystems, those systems of water, air, plants, animals, our systems of care, would begin to fall apart. And as they fall apart, so do we.

As we continue to see an increase in anxiety, depression, and even psychosis as our systems of care collapse, we can look to the Afro-Indigenous traditions that survived the Middle Passage for guidance and relief. These oral traditions, rooted in Nature, were passed down through the bodies, minds, and spirits of West Africans who survived the traumas of the slave trade. These traditions still live and are practiced by hundreds of initiated persons in the United States, London, Brazil, Mexico, Trinidad, and everywhere Black people were kidnapped and taken throughout the African Diaspora. In fact, some say the traditions are more alive in the Diaspora than in West Africa, as Christianity and Islam are the religions that are more commonly practiced there. I have been initiated in the Afro-Cuban Lucumí lineage for thirteen years and continue to learn and teach under the guidance of my Elders, Michael Atwood Mason Oñí Ocan, Priest of Ochun—and Josette Williamson—Oyalade, Priestess of Oya.

I'm reminded of what the Elders have been saying for years:
What we do to the Earth, we do to us.

Afro-Indigenous technologies, such as earth-based divination systems, are used to communicate with the Ancestors and the Spirits of Nature as a form of medicine. These technologies are used to assess, diagnose, and "prescribe" the medicines and ceremonies necessary to maintain and nurture one's balance and manifest one's destiny. As a diviner, I am able to interpret the messages and instructions that come through the shells and stones. Messages such as:

What we do to the Earth, we do to us.

Our Ancestors are unsettled, we must make amends, and offerings, and repairs, and change our behavior for the healing of our lineages.

We must continually cultivate our inner strength to be able to withstand the shocks, and jolts, and hits that result from an Earth out of balance.

They prescribe the following treatments:

Sing—sing every day to the waters, to the plants, to the stones, to our ancestors.

Dance—on the Earth, jump, wiggle, shake our bodies.

Grief is good medicine—let tears flow like the river.

Keep ourselves clean in body, mind, and spirit; refrain from cursing and gossip.

Clean our heads with fresh water.

We are taught that these are not merely acts of spiritual devotion. Rather, these are mental health practices for survival because as things fall apart, we do these things so that we do not fall apart.

...it is more important than ever to have Indigenous experiences and voices partnering on wildfire strategies that are both effective and socially just. DR KIRA HOFFMAN

DW

FIGHTING FIRE WITH FIRE

ADAPTING INDIGENOUS PRACTICES

DR. KIRA HOFFMAN

Fire Ecologist

Dr. Kira Hoffman is a Canadian fire ecologist who practices prescribed burning and supports Indigenous-led fire stewardship. Her areas of restoration and study of fire histories include Garry oak meadows, the Edziza Provincial Park, caribou recovery, temperate rainforest fire research, and dendroglaciology. In my favorite video clip of Kira at work, she has on a Barbie-pink hard hat and firefighting gear as she guides a torch of fire through a forest bed of dry grass, leaving behind a trail of crackling orange flames. Watching it, I realize a couple of things

simultaneously: that it's empowering to see a female scientist taking on preventative forest care practices, and that I don't know much about fire other than to fear it and the damage it can cause. To use fire as a crafting tool, as if drawing with flames to mark a boundary for preventative burning, is creative work. Kira's illustrated seasonal fire calendar is a hot take on an enormous issue: the climate crisis. When art and education meet community-centered research, we have a fighting chance to make small, impactful changes. I also think it's a beautiful way of addressing something we have come to fear but must learn to live with.

This seasonal fire calendar is designed to show how Indigenous peoples have used fire for millennia and how we can all learn to better coexist with fire. It's about changing the narrative from fire as a frightening disaster that you see on the news to a tool that is used year-round to increase the health of ecosystems and human communities.

Please feel free to download the illustration in black and white from her website (https://www.kirahoffman.com/media) and color it in with your younger (and older!) friends and see what interesting conversations might be sparked or who might want to be a firefighter when they grow up! Color it, study it, and learn about these ancient traditions.

I WAS EIGHT YEARS OLD the first time we burned the fields at our farm in Northern British Columbia. It was a warm spring day, and when the wind picked up in the afternoon the fire made us run with hoses to contain it. From that moment, I felt drawn to the power of fire. A few days later, as the grass turned fluorescent green, I learned how fire can be a very important part of healthy ecosystems. I've been involved in fire ever since, as a helitack firefighter, as a fire ecologist,

and now as a fire practitioner working with Indigenous communities to support returning to burning across traditional territories that were managed for millennia with fire stewardship. Because fire was excluded from the land base for so long, there is now a buildup of dense and dry fuels in the forest. As the climate becomes warmer and drier and fire seasons lengthen, using fire as a tool to mitigate the impacts of increasingly severe fires and as a tool to increase the productivity of important foods and medicines is critical.

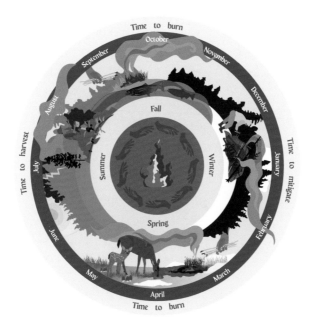

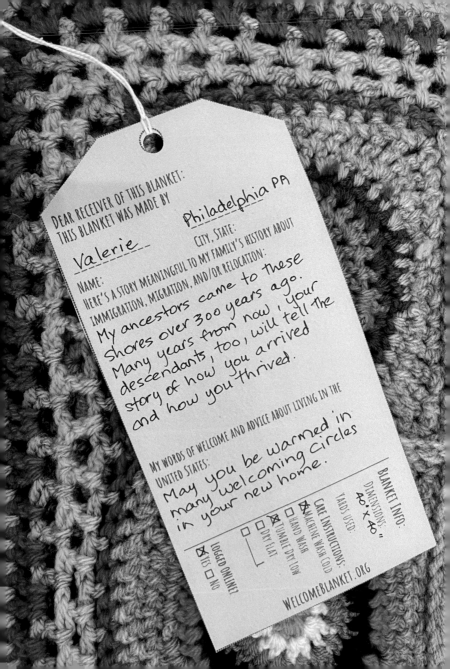

DEAR RECEIVER OF THIS BLANKET:
THIS BLANKET WAS MADE BY

Philadelphia PA
CITY, STATE:

Valerie
NAME:

HERE'S A STORY MEANINGFUL TO MY FAMILY'S HISTORY ABOUT
IMMIGRATION, MIGRATION, AND/OR RELOCATION:

My ancestors came to these
shores over 300 years ago.
Many years from now, your
descendants, too, will tell the
story of how you arrived
and how you thrived.

MY WORDS OF WELCOME AND ADVICE ABOUT LIVING IN THE
UNITED STATES:

May you be warmed in
many welcoming circles
in your new home.

BLANKET INFO:
DIMENSIONS:
40" X 40"
YARDS USED:

CARE INSTRUCTIONS:
☒ MACHINE WASH COLD
☐ HAND WASH
☒ TUMBLE DRY LOW
☐ DRY FLAT

LOGGED ONLINE?
☒ YES ☐ NO

WELCOMEBLANKET.ORG

WELCOME BLANKET

JAYNA ZWEIMAN
Activist, Cofounder of Pussyhat Project

While recovering from a life-changing head injury and unable to continue working as an architect, Jayna Zweiman found knitting and crocheting to be critical to her healing. Her crafting eventually evolved into communal practices and projects, including the massively famous Pussyhat Project, a social movement to advance women's rights as human rights. Now, Jayna invites us to help her make Welcome Blanket an American tradition by combating xenophobia through craft and community.

IN A TIME THAT CAN BE INCREDIBLY DIVISIVE, we can come together to welcome new refugee families to the United States in a kind, creative, collective, personal, and powerful way. Welcome Blanket focuses on providing a warm, creative, and collective embrace to our most recent neighbors as they start a new chapter in the United States.

Welcome Blanket recognizes and honors that we all come from somewhere. The project connects us with our refugee neighbors through sharing stories and symbols of welcome.

I started Welcome Blanket as a long-term effort to combat xenophobia and create a new American tradition that reimagines the message of welcome, celebrates our complex collective American narrative, and crafts a world we all want to live in.

Since 2017, more than seven thousand blankets have been crafted and gifted with love. Makers reflect the diversity of this country: the youngest was 4 and the oldest 104. Our open community includes

Christians, Muslims, Jews, Buddhists, and atheists; and there are makers from a wide range of political leanings. Many participants have diverse migration stories—from being descendants of slaves to displaced Native Americans, from recent refugees to descendants of the Mayflower passengers.

I am the proud granddaughter of refugees and immigrants and the product of the American dream. As cofounder and cocreator of Pussyhat Project, I know firsthand how collective craft activism can hold power and warmth. As a person with a disability, I am interested in the diversity of accessible ways people can participate as unique individuals and be part of a collective force.

Displacement, migration, and immigration can be abstract terms, but they become real when we connect them to ourselves and our neighbors. In the end, these terms (regardless of whether our families arrived last year or one thousand years ago) connect to all of us. How we choose to welcome "others" to our communities defines who we are and crafts who we can become. Welcome Blanket is a project that can make our aspirations a reality, our connections meaningful, and our experience shared.

How it works:

Handicraft makers (knitters, sewists, quilters, crocheters, weavers, felters, etc.) of all levels are invited to make Welcome Blankets. With your blanket, we invite you to include stories important to your families about immigration, migration, or relocation. These stories weave together our pasts with our new neighbors' present experiences as we craft a future together. These symbolic and practical gifts of welcome are collected, cataloged, and displayed at art institutions.

During these exhibits, we create spaces to amplify the message of welcome by hosting crafting circles, performances, discussions,

forums, and legal assistance for immigrants. After each show's close, our thirty-plus partner refugee organizations present these tangible gifts to welcome our newest neighbors.

Below are the steps for making your Welcome Blanket, alone, or with friends, neighbors, or family. But if it's not for you, there are many other ways we "welcome" your participation—as a connector, a host, a fundraiser, a writer, an organizer, and so much more.

We welcome you.

INSTRUCTIONS

1. Craft a blanket that is 40" x 40" in any medium that is easy to care for. It should hurt to give it away because you LOVE it so much. All levels are welcome, and below is a knit pattern to get your juices flowing!
2. Write a welcome note sharing a story important to your family about immigration, migration, and/or relocation.
3. Log your blanket online and send it to our rotating host. Since 2017 we have ALWAYS had a place to receive your work. Check www.welcomeblanket.org when you are ready to send your wonderful contribution for the most current host information!

"COME TOGETHER" BLANKET

BY KAT COYLE

We love this pattern because it can be done in pieces—you can knit on the go and you can knit as part of a group. Each square measures 10" x 10", and the simple project comes together in a 4-piece x 4-piece square. Use two colors, ten colors, go wild!

If you are using different yarn from the suggestion below, that's fine! If it's your first project, welcome!

40" x 40" LAP BLANKET

MATERIALS

Universal Yarn Deluxe Bulky Superwash (100% superwash wool; 106 yds/97 m per 3.5 oz./100g). 6 skeins each: MC: #936; CC: #934.

Needles: US 1⅛ mm straight (or size needed to achieve gauge)

Tapestry needle

GAUGE

12 sts and 24 rows = 4" in garter stitch

DIRECTIONS

Make 16 squares:

1. With MC, CO 2 sts.
2. Row 1: K1, inc 1 (with backward loop), k to end.
3. Rep row 1 to 46 sts (or 10" measured along right edge).
4. Break yarn; join CC.
5. Next row: K1, k2tog, k to end.
6. Rep last row until 2 sts remain.
7. Next row: K2tog. Fasten off.
8. Finishing: Arrange squares and whipstitch together.
9. Neatly weave in loose ends.

BANNING TOGETHER

AGAINST BANNING BOOKS

PEN AMERICA
Nonprofit

ASH + CHESS
Artists

PEN America is a nonprofit that has been working since 1922 on behalf of writers, artists, and journalists to protect their free speech, safety, and freedom of expression worldwide. Fighting against the banning of books is essential to our creative growth as a nation and as individuals. I've stitched many quotes from banned books to highlight and share their importance.

BOOK BAN FACTS

- 5,894: The number of instances of books banned across the 2021–22 and 2022–23 school years, according to PEN America.
- 37 percent: The portion of those banned books with characters of color or themes of race and racism.
- 36 percent: The portion of those banned books with LGBTQ+ themes or characters.
- Florida: State that accounted for more than 40 percent of book bans in the 2022–23 school year.
- A number of states have enacted legislation that limits education about sexual identity or "divisive concepts," including race.

SIMPLE ACTIONS TO FIGHT BOOK BANS IN YOUR AREA

1. Read and talk about banned books!
2. Write and decorate a thank-you note for your local librarian.
3. Design a bookmark to protest book bans.
4. Read a postcard with your concerns at your local school board meeting.
5. Go to pen.org/action to find out how else you can help.

BOOKS BANNED IN THE 2022–23 SCHOOL YEAR

- *The Bluest Eye* by Toni Morrison
- *Gender Queer: A Memoir* by Maia Kobabe
- *The Handmaid's Tale* by Margaret Atwood
- *Milk and Honey* by Rupi Kaur
- *All Boys Aren't Blue* by George M. Johnson
- *The Hate U Give* by Angie Thomas
- *Red, White, and Royal Blue* by Casey McQuiston
- *Last Night at the Telegraph Club* by Malinda Lo
- *Slaughterhouse-Five* by Kurt Vonnegut
- *Flamer* by Mike Curato

BANS OFF OUR BOOKS

Ash + Chess is a stationery and gift company run by queer and trans couple Ashley Molesso (she/her) and Chess Needham (he/him), based out of Kingston, New York. By bringing books and art instruction that celebrate diversity into the world, they invite us to exercise creative vigilance when it comes to our freedom of expression.

READING IS A SAFE WAY to access a world beyond the scope of your immediate environment. We should strive to make this more accessible, not less. The more we read and learn about others, the more compassionate we become. Censoring books leads to oppression, as taking away this tool of learning shows what people who ban books are really scared of: an imaginative world in which people are compassionate to those around them.

—ASH + CHESS

My great grandmother Rose
mother of Ashley gave her this sack when
she was sold at age 9 in South Carolina
it held a tattered dress 3 handfulls of
pecans a braid of Roses hair. Told her
It be filled with my *Love* always
she never saw her again
Ashley is my grandmother
Ruth Middleton
1921

A sack given by Rose to her daughter Ashley in the mid-1800s. The story of the sack was stitched by Ruth Middleton, Ashley's granddaughter. Courtesy of the Middleton Place Foundation, Charleston, South Carolina.

CRAFTING A

HISTORY
OF LOVE

TIYA MILES
Author, Public Historian

*Tiya Miles is a professor of history at Harvard University, a public
historian, and a creative writer. She has authored numerous books that
reflect her dynamic and rigorous approach to public history, including
the book that brought us together,* All That She Carried: The Journey
of Ashley's Sack, a Black Family Keepsake. *When it was first published,
followers flooded my inbox with links to Tiya's book and articles
about Ashley's sack, an antique cotton grain sack from the 1850s with
embroidered text, the keepsake at the center of the book's narrative.
Although my personal brand of craftivism has focused on stitching
current political discourse into vintage textiles, I felt an immediate kinship*

with the sack as an important personal and historical artifact. Textiles and embroidery are narrative tools that have the ability to summon emotions and capture history. I chose to feature Tiya's work in this book because the story of Ashley's sack speaks to some of the themes of craftwork: the archival narrative nature of textiles, making a gift of love out of available materials, the desire to be seen through making, and the use of thread to illustrate language. Her writing about Ashley's sack gives us a window into the way our work, our craft, and our creative choices might later be interpreted.

Tiya decided to write about Ashley's sack, but she faced the challenge of crafting a book despite a lack of available information about the sack or its owners. So Tiya decided to interweave additional story threads into her book, starting with her own emotional encounter with the sack. A sense of sadness, awe, beauty, and loss filled her with a compelling desire to honor the Black women who endured intergenerational trauma of slavery to leave behind evidence of their love. Tiya's crafting of her book was informed by the twists and turns of research, by a willingness to lend her voice to interpretations, and by revisiting her own family narratives and the work of writers, artists, and poets. She has said that creative writing is the best kind of writing to help us explore the human interior, a "submerged space" that traditional scholarship alone cannot reach.

Tiya was once asked how we can emerge from intergenerational trauma. She replied that she looks to Black women of the past, her ancestors, and other historians. They teach us that if we grasp on to love with as much strength and perseverance as Rose and her descendants, we might find some answers. The sack, as it turns out, may be empty, but it is filled with love.

When Rose's daughter, Ashley, was sold into slavery, she gave Ashley a simple sack and filled it with what she had to give: a dress, three handfuls of pecans, a braid of her hair, and love. Why are we crafting and stitching if not to be remembered for and reminded of our love for each other? We give what we can. Three generations later, when Ruth stitched text into the sack, she made "love" the largest word, and ensured that anyone who saw it would also know something of its story. By sharing its personal significance, she gave it public importance. This is something I have seen over and over again with craft: when you outwardly manifest the personal, it is given a public life.

Tiya's interpretation of Ruth's work firmly cements the sack's present place in history:

BY CHOOSING TO WRITE THROUGH STITCHES, Ruth transformed her fabric canvas into a document, a written record of past events. This decision, similar to her election to work in a "feminine" form, elevated the cultural resonance of her creation. By scripting a family history onto the bag that was core to the story, Ruth accomplished two crucial feats: she succeeded in attaching a special story to a precious object, permanently joining them together so that neither would be forgotten, and she entered her family's humble sack into the written record from which histories of the nation are made.

Ruth turned the story she had heard through the years into a remarkable document, a written record with the cultural power to augment history. . . . In her act of retelling a story she had been told in order to fix it in permanent form, Ruth Middleton, a domestic laborer, became an oral historian—a collector and interpreter of evidence, a preserver of knowledge about the past.

Later she writes about Ruth's choice of thread color:

Ruth's use of the color red combined with an emphasis on emotion taps into shared human associations with archetypal tropes. Cloth work, Ruth's medium, gathers its communicative power through broad symbolic imitation and association on a relatively permanent material.

twenty ONE
onward through THE
 LIMINAL
wan.der.lust
love and air
stitches

crafting web
embellish life
storytelling core
 to live
 and inspire

at the edge of nature
FREEFALL RENEGADE
We are always coming home

trails of OVERGROWN memories
 home town.
LOVE THE THREAD
catch my SOUL

SCRUB Ḛ NEW
me together
return to rethread
aspire homeward

LOVING THE THREAD

NATALIE CHANIN

Entrepreneur, Fashion Designer, Founder of Alabama Chanin and
Project Threadways

*Natalie Chanin is an inspiring creative and small-business owner based in
Florence, Alabama, who has over two decades of experience in a culturally
sustainable, focused approach to design, craft, and education. Her business
promotes local artisanship, teaches classes in continuing education
for stitching technique advancement, and is also very environmentally
friendly: Her locally hand-stitched designer clothing is crafted in a former
T-shirt factory, where every scrap of fabric is put to use.*

*I collaborated with Natalie on a collection of twenty-one one-of-a-
kind jackets, each embroidered with lines from a collection of verses that*

represents Project Threadway's journey over twenty-one years of making. Our poem, "Twenty-One Years: A Journey," tells the story of the creative pursuit and the art of making:

onward through THE LIMINAL / wan.der.lust / love and air / stitches / crafting web / embellish life / storytelling core / to live / and inspire / at the edge of nature / FREEFALL RENEGADE / we are always coming home / trails of OVERGROWN memories / home.town. / LOVE THE THREAD / catch my SOUL / SCRUB ME NEW / me together / return to rethread / aspire homeward.

You can use the technique below from Natalie to design your own T-shirt representing a slogan or some other political message using Reverse Appliqué (from pp. 90–91, Embroidery: Threads and Stories *by Natalie Chanin).*

REVERSE APPLIQUÉ IS THE FIRST TECHNIQUE artisans and guests to our studio learn; it is the core of our entire stable of techniques. The simple number of stencils grew to include roosters, eagles, and flowers. These stencils were inspired by rural life, the community, historic textiles, cutting-edge fabric design, and more. Using these, reverse appliqué T-shirts were created, produced, shipped to stores around the globe, and photographed by major fashion magazines as our cottage industry–inspired business model garnered attention from journalists, culture writers, and entrepreneurs. Over time, the simple stencils and stitches of these first T-shirts developed into elaborate designs that used an array of stenciling, hand-painting, threads, yarns, materials, and techniques in multiple layers that required detailed fabric maps to be replicated by artisans whose skills grew in lockstep as the designs evolved—all inspired by basic reverse appliqué.

SLOGAN T-SHIRT PROJECT

MATERIALS

Stencil or design for project

Textile paint, marker, or other method to transfer stencil or design onto project

T-shirt or fabric for top layer of project

Backing fabric that is slightly larger than your stencil or design

Pins

Needles

Button Craft Thread

Embroidery scissors

DIRECTIONS

1. Using a stencil with paint or textile marker, apply your design to the right side of your T-shirt or top-layer fabric, and let the design dry thoroughly. Follow any manufacturer instructions for setting materials permanently.

2. Place the backing fabric, right side up, behind the stenciled area of the top layer fabric to be appliquéd, and pin into place.

3. Using a straight stitch, stitch the two layers of fabric together along the edge of each design or stencil shape, beginning and ending each shape with a double knot.

4. Using sharp embroidery scissors, clip a small hole in the top layer and inside your stitched shape, being careful to only clip the top layer of fabric. Insert the tip of your embroidery scissors and carefully trim away the inside of the shape, cutting about ⅛" to ¼" (3 to 6 mm) away from the stitched outline.

5. "Loving" your thread infuses the work with kind intentions, but it's also a very practical step that removes excess thread tension and prevents pesky knotting.

6. Here's how to love your thread: cut the thread twice as long as the distance from your fingers to your elbow. Thread your needle, and pull the two thread ends so they're the same length. Hold the doubled thread between your thumb and index finger, and run your fingers along it from the needle to the end of the loose tails while saying, "This thread is going to sew the most beautiful garment ever made. The person who wears this garment (use their name if you know it) will wear it in health and happiness; it will bring joy and laughter."

7. Continue loving that thread, wishing it all the good that you can think of, and running it through your fingers again and again. What you're actually doing is working the tension out of the tightly twisted thread with rubbing, pressure, and the natural oils in your fingers. In the process, you've also taken a moment to calm the tension in your mind, concentrate on the task at hand, and add just a little bit of love to your garment or project. Now you're ready to tie off your knot and start sewing.

8. Make a double Overhand Knot: Thread your needle and even the ends to create two strands of thread. Make a loop about 2" from the

cut ends of the thread and bring both ends through the loop. Use forefinger, thumb, or both to nudge knot to about ¾" from the cut ends. Then repeat to make a double knot.

9. Bring the needle through to the desired side of your fabric on your final stitch, smooth the tension from the stitches, and make a loop with the thread; then pull the needle through the loop, using the forefinger, thumb, or both to nudge knot into place, flush with fabric.

10. Then repeat the process to make a double knot.

11. After making a second knot, cut the thread, leaving a ½"-long tail. And now you are ready to start sewing.

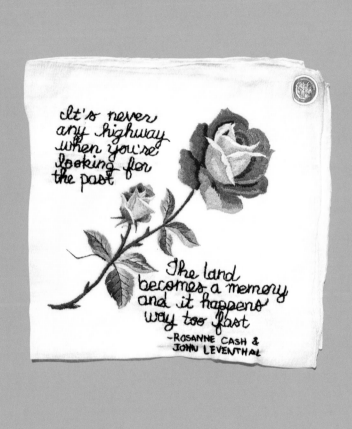

THE CRAFT OF BECOMING AND BEING

AN INTERVIEW WITH ROSANNE CASH
Musician, Author

Rosanne Cash is an American singer-songwriter, author, and recreational knitter. In the fall of 2019, just before the pandemic, I met her at a sewing circle in Maira Kalman's living room. Rosanne was stitching a Trump quote for Tiny Pricks Project. *We discussed the implicit tension in combining her love of thread and textiles with his vile words.*

Rosanne Cash is a beginner's mindset inside an old soul. Her creative instincts, artistry, intelligence, awareness of her family's musical legacy (her father was the singer Johnny Cash), and thoughts about the evolving landscape of this country have made her great artistic company through challenging times. One of the things I admire so much about Rosanne is her candor when it comes to what it requires to follow

a creative path: sacrifice, painful personal growth, vulnerability, and a willingness to change course when your unique potential is elsewhere. She has crafted a career out of many different chapters, places, losses, and influences and is wholly herself.

Four years after we first met, I interviewed her as she was recovering from knee surgery and celebrating the thirtieth anniversary of The Wheel *with an expanded rerelease. The original album came out of a time in Rosanne's life when everything changed: her marriage, work, and lifestyle.*

DIANA: We were supposed to meet in April 2022 in Florence, Alabama, at the Project Threadways Symposium at the Alabama Chanin factory. About ten days before the event, I went to a dinner party. Three days later, I had COVID. I was crushed. I resigned myself to isolation and participated virtually an hour before you and John performed in person at the conference. I was sorry to miss being with you in the landscape that inspired you to write *The River & the Thread*. The Tennessee River. Muscle Shoals. Still, it was a minor disappointment compared to what so many had been through. What were some of your experiences during the pandemic, and what got you through the challenging ones? What was it like to be back in that landscape during that time?

ROSANNE: I used to daydream as a child that I had a cave, and in that cave were all the books and music I loved, and paintbrushes and easels, and a window into the ocean, and films, and a million things I was curious about. In this cave, no one could bother me, no one could ever knock on the door, no one knew where I was. The pandemic offered a wisp, a taste of that. I was burnt out from being on the road and tired from the intensity of my various work projects. I actually loved that I couldn't leave my house, and then, after some

weeks, that I only left for a walk through the empty streets of Chelsea. It could feel apocalyptic if I let myself go there, but mostly it felt like a universal and personal reset. I cooked, baked, watched films, read short stories and essays (I found it hard to concentrate on long-form written work), sewed, and wrote a bit. I wrote a piece for *The Atlantic* called "I Will Miss What I Wanted to Lose," about my complicated relationship with touring, and how the pandemic had given me a bigger window to a future without constant travel and one-nighters. John and I also did 15 or 20 virtual home concerts, mostly for benefits for struggling concert venues, tributes to health-care workers, to help other musicians stay afloat, and we even did a full concert with guests performing virtually from afar for Carnegie Hall, who sent their own vaxxed and masked film crew to our studio. I'm fully aware that this is the experience of a very privileged person. I had enough money and space, a little garden, and my husband and son for the journey, and it turned out to be restorative. John and I wrote a song leading up to the scary 2020 election called "Crawl into the Promised Land," and my son shot a video for it in our recording studio and on the streets. I wrote a song called "The Killing Fields" during the George Floyd protests and felt the veil of white privilege lift just a bit, just enough to know that I don't know much, but I can feel deep empathy and the pain of my own ancestral history of slaveholders, and the dark history of my father's birthplace of Arkansas. A lot of deep interior work went on during the lockdown. I didn't write *King Lear*, as Shakespeare did during a plague lockdown, but I did touch some creative wells that were waiting for me.

DIANA: You have spoken about "loving the thread," a phrase you first heard from Natalie Chanin, founder of Project Threadways and Alabama Chanin, being about deciding what to connect with and what to cut. I also understood it as the process of straightening the thread to

release it from the memory of the way it has been wound and stored. What does it mean to you now?

ROSANNE: Oh, there are so many levels to that comment she made. As you say, releasing it from memory. Cutting what is binding me, not serving me, while I love what I've learned. Doubling, strengthening, making taut the threads to my past and ancestral past that have given me my tenacity and art, but loosening and sometimes cutting some old, painful cords. Then, of course, there is the pure exhortation to love my handiwork, smooth that thread so it glides through the needle and fabric, and follow where it leads.

DIANA: In your book *Composed: A Memoir* you wrote, "I want to live inside the world," and I was reminded of the tension so many artists feel between their interior and exterior worlds. Your book is a wonderful combination of these competing impulses. Do you relate to the challenge of deciding what to do with the day? Do you find days when you have work to do easier? What brings you inside the world?

ROSANNE: I have always had trouble grounding myself. It's been a lifelong process, and something I've had to teach myself. I think if I work hard enough that I personally can enact gun control and ban assault weapons, and of course I cannot. But I do feel a powerful mandate to not shut up about it, to perform at the benefits for various anti–gun violence and pro–gun control organizations, the house parties, write the op-eds, march, speak . . . I once did a lie-in with about 25 women in Times Square. (Ewww.) Maybe it doesn't change things but maybe little by little . . . If I'm consumed by my justice instincts, then it's hard to savor. Sometimes I, too, want to wander and savor, and I give myself those opportunities regularly. Balance is good.

DIANA: Again, from your book: "creative work sometimes fosters a prescience . . . a release from linear time, [to be] somewhere other than

the present." I have been thinking about this relative to grief or other times when we need a release from the present. When I lost my father just over a year ago, stitching grounded me. What different kinds of creative work are you engaged in right now? (Including blankets for grandchildren!)

ROSANNE: I found, too, that creative work—mostly writing—was a tonic during periods of deep grief. It gave me a more universal understanding of grief, and put my personal grief in a more manageable perspective. That couldn't last all day every day, of course, but the window it provided was expansive. Right now, I'm writing. John and I are six years into writing a musical—he is the composer, I'm the lyricist, the great John Weidman is the book writer. We are nearly finished, but there are rewrites and a couple of new songs to write. I also recorded a duet with the National, which was thrilling and is on their new album. I recorded a Lou Reed song for an upcoming tribute record to him. I just sang on Lola Kirke's new record, and I'm writing songs for a new album. I wrote one with Matt Berninger of the National, which is soooo beautiful, if I do say so myself. I can't wait to record it. I'm also working on the baby blanket!

DIANA: I was struck by the scope of family history shared in your book, going back not just to your father, Johnny Cash, but generations before. You write so well and capture beautiful snapshots of so many people. It feels like such a warm embrace of all the past. Was your book written for your family or more for a broader audience? A place to put it all when places, landscapes, homes, and people change or are gone?

ROSANNE: Honestly, I didn't write it for anyone but myself. My family story has been co-opted thousands of times. The myth of my dad, the vilification of my mother, the projections onto my dad

of who he was and what he believed, the pushback on me when people think I diverge from the Cash family ethos, the dispiriting experience of people thinking they know more about you than you know about yourself. Fame is bizarre. At one point I thought, if I don't tell my story, it will continue to be co-opted and distorted forever. I knew that there was no way I could "correct" perceptions of me, or change public opinion, but it didn't matter. I had to plant my flag for myself.

DIANA: We live in reaction to our parents. You write about your parents having different outlets for their creative lives. Your father had a vast forum for his emotional life. Your mother had a more domestic forum. Do you find value in both? The public and the private? The arts and the domestic arts?

ROSANNE: Absolutely. I have a fairly well-developed sense of balance for both.

DIANA: It seems that there was a point at which you became an activist when you were very pregnant, handing out voter registration cards in your painting class. What are some of the issues that matter to you the most now? How have you used your love of language for activism?

ROSANNE: Gun control. The number one killer of children and teens is GUNS. This is unacceptable in a civilized society, and it's an extension of parenting to work to change that. The politicians in the pocket of the corporate gun lobby turn my stomach. There are feeder streams into sensible gun policy and number one, of course, is voting. The percentage of eligible voters who actually go to the polls is beyond dispiriting. Hence, handing out voter registration cards in a painting class moments from giving birth.

DIANA: I feel like your book is a wonderful guidebook for a creative life, and to know your work is to get to know you.

ROSANNE: Yes, I feel the same about my songs. Even the songs that are clearly 3rd-person songs, I'm still there. I have a kind of Celtic melancholy in my DNA that runs through my work.

DIANA: Your lyrics suggest that home can mean so many different things, and we're all walking toward it. Are there ways in which issues of social justice and activism have helped you on your way home?

ROSANNE: I went to the Million Mom March for gun control in Washington in 2000 and spoke at the event, and wrote about it for *Rolling Stone*. A few friends went with me, as well as my husband and then 11-year-old daughter and baby son. I was caught up in the day, and the fact that I was going to speak, and looking out for the kids, and then, as we were about to start the march, I looked around and there were thousands and thousands of mothers quietly holding pictures of their dead children, who they had lost to gun violence, just waiting for the signal to start marching. I was overcome, and turned to my friend Patty Smyth and said something about how helpless I felt. And she said, "Today, we're just here to help carry the burden of the grieving moms for one day." As you say, we are walking each other home, bearing witness.

DIANA: What does it mean to say yes to all of it right now? What secrets are you listening to these days?

ROSANNE: I'm recovering from knee replacement surgery right now and my friend Maria Popova reads a poem and sends me a voice text of it every day. It's a beautiful little secret. I'm also listening to the secret of pain. It's a painful recovery and pain is such a singular and lonely world. I've listened to Larkin Poe's "Southern Comfort," the acoustic version, about a hundred times in the last few days. It's a secret comfort, but I couldn't tell you why.

DIANA: Where do you think we are now, America: 2023?

ROSANNE: Something terrible has been unleashed in the world and it scares me. I don't understand the depth of hatred and ignorance, and the lack of compassion. Gun control has been at the center of my activist instincts for a quarter of a century now. Things are worse, but I'm not going to shut up about it. The corruption of politicians on the payroll of the corporate gun lobby is pure evil. Senator Marsha Blackburn in Tennessee, after those children and teacher were killed at Covenant School, posted that she stood by "ready to help." Help what? Wash blood off the walls? She took over a million dollars from the gun lobby and a few months later welcomed a new Smith & Wesson factory to Tennessee.

DIANA: What are the honest voices that you seek out right now as we navigate these intense times?

ROSANNE: Those who are deeply in touch with their own humanity, and act out of compassion and wonder. Those who are comfortable with questions. Those who don't add fuel to the darkest part of their nature. Artists.

DIANA: You have been quoted as saying, "Art, in the larger sense, is the lifeline to which I cling in a confusing, unfair, sometimes dehumanizing world." I very much appreciate how much you both cling to art and make art to let go of. How has that helped you during confusing, unfair times?

ROSANNE: I'm clinging to it right now. Music is the language behind language, how we communicate when we can't communicate. There's a song for every experience and every feeling, and music can uncover buried memories, inspire, release, guide, reveal us to ourselves, and connect us to each other. It's how we talk to each other when we can't talk, in my experience.

CRAFTING

A SOCIAL
JUSTICE
BANNER

SARA TRAIL

Founder of Social Justice Sewing Academy, Nonprofit

*Sara Trail is a trailblazer and the executive director of Social Justice
Sewing Academy (SJSA). She wrote her first book at thirteen,* Sew with
Sara, *created a DVD at fifteen, has designed two fabric collections, made
a quilt in memory of Trayvon Martin while at UC Berkeley, and went to
Harvard's Graduate School of Education. I've been on panels with Sara
during which I've taken notes as she spoke. As a volunteer contributor to
the SJSA Remembrance Project, I made a block for a community quilt in
honor of a victim of social injustice. This is the information SJSA emailed
to me:*

Name: Tylyike Akiel Pigford
Age: 24
City, State: Wilson, NC
Year of Death: 2020

The instructions to make the quilt square came with a statement of compassion: "We understand this is an emotional task, and acknowledge it is being done with care and concern." This kind of concern, shared by SJSA, is one of the many reasons their work is so effective and essential.

SJSA IS A NONPROFIT ORGANIZATION that encourages individuals to intentionally engage with the intersection of art and activism by creating textile art that centers social justice. We envision a world in which textile art is a catalyst for raising awareness of local and national issues affecting marginalized communities. We encourage people, especially youth from disadvantaged backgrounds, to identify as "art-ivists" and create art that speaks to social justice issues that they care about, giving them an opportunity to express their views. The art that is created with SJSA is often created in and permeates throughout different spaces, including schools, jails, museums, and universities, reaching broad and diverse audiences. Our goal is to help cultivate safe spaces for dialogue, awareness, and empathy. SJSA recognizes the importance and the civic duty of voting at all levels of government. We encourage individuals to have their voices heard by voting for officials who reflect and uphold their personal views and values. We also recognize that institutions of power, especially within the United States, have historically been oppressive toward and discriminated against many marginalized communities. Therefore, the work that we do at SJSA aims to empower these communities.

The textile art project outlined below is an opportunity for you to express yourself, as well as show support for and solidarity with those who are marginalized, specifically during the upcoming presidential election. It is our aim that you create art that represents the hope for true empowerment of those who are systematically disadvantaged—a hope that we all collectively share.

Historically, fabric art has played a central role in social justice movements around the world. In many ways, art is translatable across cultures, art inspires people, and most importantly, art can easily be used to educate others. The instructions below will guide you in creating your unique fabric art banner that speaks to social justice issues.

Because the goal of this project is to show solidarity about social justice issues that you feel passionate about, the banner should also reflect your personal values. Before you get started making, take some time to reflect on topics that you care about. Some examples could be food insecurity, racial equality, gender equality, access to health care for all, women's reproductive rights, police brutality, or global warming. After reflecting on your values, determine which one(s) you would like to create an artwork for.

SOCIAL JUSTICE BANNER PROJECT

Here are three main guidelines for creating your social justice banner:
Make your message straightforward. We estimate that people will initially interact with your banner for about three to five seconds, so we encourage you to keep your message simple by using six words or fewer. One of the coolest things about social justice art is that it's easy to understand right away. This makes the art more impactful, as it can be understood across different generations and cultures and inspire people to take action.

Use well-known symbols. Again, your banner should be able to be understood by a diverse audience. Well-known symbols can be a great tool to meet this need: the peace sign, a four-leaf clover, or a dove symbolizes peace and transformation.

Use a collaging technique. This banner will be made out of upcycled scrap fabric, which means that collaging is the perfect approach. Feel free to collage aspects of the banner background or the entire surface to create the perfect setting for the main symbol or message. When you collage the fabric pieces, you have more opportunity to overlap colors and fabric designs, create depth, and give the art more visual appeal and individuality.

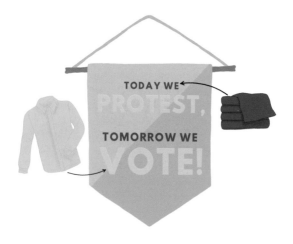

MATERIALS

Scrap fabric (we love to upcycle!) of any size or shape

Thick muslin or quilting weight fabric

Cording (used to hang banners)

Dowel (for the top of the banner)

Fabric scissors

Glue

Thread

Needle

Measuring tape

Optional: sewing machine, fusible interfacing, binding

DIRECTIONS

1. This fabric is the base of your activist banner. Take your fabric and cut it into a rectangle—any size will work—there are rules and there is no "right" way to create an activist banner.
2. You can upcycle materials! Using old T-shirts, pillow cases, or sheets, you can cut out shapes, letters, and images that will be glued to your activist banner base.
3. Now it's time to layer! All of the shapes, letters, and images you have cut out get glued to your banner. Use iron-on fusible tape if you are using thicker material (denim or thick canvas), or you can hand- or machine-sew them on!

We encourage you to display your banner(s) in your classrooms or home windows, or post them to social media as a way to show allyship, solidarity, and a commitment to education.

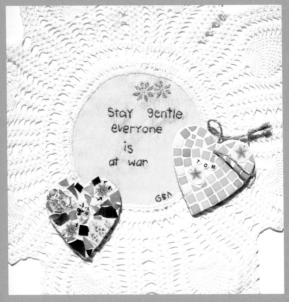

Embroidery and yellow heart by Gisele. Second heart by Diana during a workshop with Gisele.

CRAFTING A

HEART

GISELE BARRETO FETTERMAN
Activist, Philanthropist, Nonprofit Executive

*Gisele Barreto Fetterman is a natural-born crafter of life. She defies
categorization, but here are just a few pieces of her life (so far!): a
formerly undocumented immigrant, Brazilian, American, volunteer
firefighter, nutritionist, mother of three, partner of Sen. John Fetterman
of Pennsylvania, promoter of thrifted clothing (especially at fancy
Washington, DC, events), advocate for mental health care, champion of
rights for people with disabilities, vegetarian, disability justice advocate,
spokesperson for Be The Match (a national bone marrow donor
program), and founder of three Braddock, Pennsylvania, nonprofits that
promote tolerance, diversity, and generosity. Gisele thinks picking up
hitchhikers is just carpooling, proudly defends her thick eyebrows, speaks
three languages, embraces all crafting opportunities, called herself SLOP
(when she was the Second Lady of Pennsylvania), rescues animals, and
believes in the health benefits of a good cry.*

After her husband Sen. John Fetterman came forward to share his battle with clinical depression and sought treatment at Walter Reed National Military Medical Center, Gisele spoke openly about living, as a family, with mental illness. She has said that her work is to ease the pain and suffering of the next person, and that she pursues endeavors that make our society better, more equal, and accessible for those in need. Gisele enters spaces thinking about who is missing, what is missing, and how the space can serve everyone.

Gisele and I first spoke a couple of years ago about our origins with respect to how we craft and make, and the community-based initiatives at the core of our work. We also spoke about our personal histories with thrifting, and how people feel when they are given something for free. I wanted to speak with Gisele again, for this book, because I think her activism takes on greater meaning in this age of income inequality, sustainability issues, and the impact of consumption on the climate crisis. Part of being crafty is working with what is at hand, and Gisele always finds a way to craft a challenge into something beautiful, something better.

Gisele is also someone who thinks about the value and dignity of making things by hand (another reason I wanted to profile her). When my father passed, she messaged to ask me his name. A couple of weeks later, a heart-shaped ornament with his name on it arrived in the mail. I was so touched that, with her husband's intense senatorial campaign and everything else going on in her life, she had stopped to make a heart by hand for me! Her simple act of crafting a gift for me while I was experiencing extreme grief connected us to each other and our love of making as if an invisible thread was pulling us back together to the things that meant the most to us.

In preparation for this book, I spent a day interviewing and crafting with Gisele in her adopted hometown of Braddock, Pennsylvania. We

sat for hours at a large wooden table, sunlight spilling through the large windows of their open space, lighting up our plastic bins of craft supplies (hers mosaic, mine stitching), while trading stories about our techniques, childhoods, hopes, children, work, and the benefits of crafting. Below are some gems from my time with Gisele that reflect the light from a well-crafted life of kindness.

- Gisele was already waiting for me as I pulled up to the back of her home, a former car dealership. (Even her home is a repurposed building!)

- She once created, under cover of night, a floral stencil and covered a section of the paved lane behind her house with white flowers in a lacy pattern that looked like icing sugar on a cake. (Craft idea number one of hundreds that come to mind during a day spent with Gisele.)

- The second order of business after getting a hug from Gisele is a proper introduction to her rescue pets. They had been adopted at different times but all experienced abuse. Levi was chained to a tree for years and beaten, but has gone on, in his new life as a Fetterman, to have a significant following on Twitter (@levifetterman). Artie was used as bait for dogfighting (she is missing a leg as a result). Potato (the cat) came to the Fettermans after being tossed out of a car and then rescued by a friend of Gisele's, who gave her a small china bowl for his food. When the cat outgrew the bowl, Gisele crushed it into small pieces and used a tiny patterned piece in a mosaic ornament for her friend. This pattern of thoughtful gifting is familiar to those in Gisele's circle: you give her a food bowl and you get back an ornament.

- Most people keep photos on their phones as wallpaper but Gisele has an actual photo wall in her home. She points out a picture of her son

dressed up for Halloween. "The kids had to come as a historical figure, so he dressed up as John. It took me forever to make those tattoos on his arm with a black marker, and then we went to a coffee shop before school and the woman asked him if he was dressed up as a convict!"

Gisele has been at the receiving end of these sorts of misunderstandings for decades. She has been mistaken for the nanny of her children when she's out with them, and the housekeeper in her own home. This does not offend her. She is more likely to feel bad for the other person than for herself. She can handle it. What is nearly impossible for her to handle is watching other people face injustice and prejudice. She stays focused on what's most important to her: using her voice for the greater good. She's collecting these challenging experiences so that she can repurpose them later. It's just a matter of time before she finds a better way to make them into something beautiful and make others happy.

- Gisele lives next door to a beautiful flower garden. The women who run it have large greenhouses on top of Gisele's house. In her kitchen is a large bouquet of flowers, a gift cut from the garden. These types of nonmonetary exchanges of resources are everywhere in Gisele's life. It's almost as if objects only exist to facilitate the personal connection, the emotional connection.

 "Every empty lot on this street was once a building," she says when we drive down Braddock Avenue. She once rescued a magnolia tree in Braddock. It now sits on an empty lot that once held a house, a home.

- We drive to Free Store 15104, one of Gisele's nonprofits, which redistributes surplus goods to neighbors in need. It is built from three connected shipping containers. The original shipping container was

at sea for about eight years and was headed for a landfill before it was upcycled for a better purpose. Free Store 15104 serves over one hundred people an hour, and visitors are told "you can have whatever you want" when they arrive.

"I get to know everyone who comes in. I know what size diapers the babies wear and what the older adults wear." Not only does everyone in town know Gisele, but she knows them as well, sometimes talking about the personal details of their lives.

At Free Store 15104, there is a wait list of over one hundred fifty potential volunteers. She once let a ninety-eight-year-old skip the wait list to volunteer: "We needed to prioritize her. I didn't want her to miss out!"

When needed, Gisele uses a translation app to communicate with store guests who don't speak the same languages she does.

The store doesn't give away furniture because most people come by public transportation. Everything must be light enough to carry away, take on a bus.

Miss Betty, who is over eighty-five years old, crochets blankets to donate to the Free Store. Kids bake goodies and paint sneakers, the Yarn Fairy from Houston donates balls of yarn, and Costco donates food. At Free Store 15104, the only currency is kindness.

- Instead of DON'T PARK here signs on Braddock streets, Gisele has posted hundreds of signs on telephone poles with messages like CHOOSE LOVE and WHEREVER YOU CAME FROM AND HOWEVER YOU GOT HERE, WE ARE SO HAPPY TO SEE YOU.
- The top of a low brick wall outside Gisele's house is covered with a mosaic she made with her children. The pieces are faded but secure.

Gisele and her family live across the street from the Edgar Thomson Works, the first Andrew Carnegie steel mill, which has been

in operation since 1875. When the train goes by her home, it feels as if you are standing on the platform.

- *When I leave, Gisele gives me a beautiful bamboo plant donated to Free Store 15104 by Costco. She points out a small brown spot on the stem, the reason it was donated by Costco, and I will now be taking it home to keep it alive. I pick some apples from the trees outside her house while a woman cuts flowers in the garden. It occurs to me that I can't remember the last time I picked an apple fresh off the tree, or when one tasted so good.*

The thing about mosaics is that they are made up of both ordinary gray cement and also tiny, beautiful fragments of glass, beads, china plates, and letters. Once they are fused together, you cannot imagine them apart.

"I always assume the best of everyone. You start to see only beautiful things, only good people, and kindness," Gisele tells me. It's another day in Gisele's beautifully fragmented world.

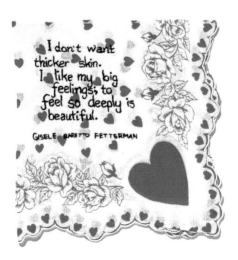

MOSAIC HEART PROJECT

MATERIALS

Weld Bond glue

A hard surface to assemble
pieces on (wood ornaments
from a craft store, wooden
board, a small cutting board,
etc.)

Mosaic glass/ceramic tile
cutting tool

Mosaic pieces: you can use old
plates, plastic letters, stained
glass, anything you can get your
hands on. (If you need to break
something into smaller pieces,
wrap it in a thick cloth and
hammer it.)

DIRECTIONS

1. Arrange the small pieces on the surface of your base, leaving some
 space between them to map for the grout.
2. When you are happy with your pattern, glue down the pieces onto the
 base.
3. Allow to dry overnight before grouting and then place the grout
 between the pieces by firmly pressing into all the cracks. Use a sponge
 to brush off excess grout.
4. Let it rest for 24 hours. Admire your art, display it proudly, or give it
 away as a gift.

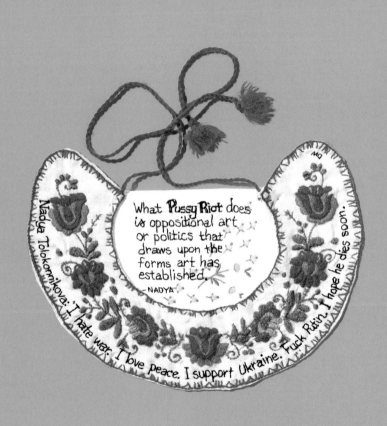

What **Pussy Riot** does is oppositional art or politics that draws upon the forms art has established.
— NADYA

Nadya Tolokonnikova: "I hate war. I love peace. I support Ukraine. Fuck Putin. I hope he dies soon."

CONVICTION
INTO ACTIVISM

NADYA TOLOKONNIKOVA

Member of Pussy Riot, Activist, Performance Artist

Nadya Tolokonnikova is a Russian performance and conceptual artist, author, musician, political activist, and cofounder of the feminist art collective Pussy Riot. In 2012, she was convicted in Russia of "hooliganism motivated by religious hatred" and imprisoned for two years. She was awarded the LennonOno Grant for Peace and shared the Hannah Arendt Prize (along with fellow bandmate Maria Alyokhina). She was arrested in absentia in November 2023 for "insulting the religious feelings of believers" and was placed on Russia's most wanted list in the wake of Putin's Ashes (2022), her exhibit protesting Russia's war in Ukraine.

Instead of retreating or being defined by her dissident celebrity status, Nadya continually rises out of the ashes of political persecution to be stronger, louder, and more creative. I invited her to be part of this book

because she has a punk attitude toward making, a DIY ethic (everything, including her body, is material), anti-authoritarian instincts, and a strong preference for personal liberty. She is also strongly individualistic and supportive of other artists, and she posts videos of her studio process. Balaclavas, red paint (blood), ashes, glass flasks, graffiti, lace, pills, sewing machine parts, pink fake fur, needles, knives, text, Virgin Mary figures, dollhouses, video, caution tape, trash, rainbow flags, feminist pictures, stuffed animals, strands of fake pearls, and dollar bills are among the many objects that appear and have symbolic meaning in her work. Below are some examples of Nadya's writing and protest art that exemplify her anti-establishment attitude as an artist-activist and her relentless commitment to justice and freedom. She has declared that art is her weapon, her instrument of war, but what I love so much about her work is her overwhelming concern for the politics of the human condition. After being released from prison in Russia and coming to the United States, she asked the mayor of New York City if she could visit Rikers Island to see the conditions there. I think of concern as something we craft out of our experiences, and Nadya is committed to crafting a better world for others so that her difficult experiences are transformed into something that serves a greater good.

EXHIBIT A: FROM *READ & RIOT: A PUSSY RIOT GUIDE TO ACTIVISM* BY NADYA TOLOKONNIKOVA

HOW TO COMBINE ART AND POLITICS

A million protest actions are possible:

kiss-in: A form of protest in which people in same-sex or queer relationships kiss in a public place to demonstrate their sexual preferences.

die-in: A form of protest in which participants pretend that they're
dead. This method was used by animal rights activists,
antiwar activists, human rights activists, gun control activists,
environmental activists, and many more.

bed-in: A protest in bed. The most famous one was done by Yoko
Ono and John Lennon in 1969 in Amsterdam, where they
campaigned against the Vietnam War from their bed.

car/motorcycle caravans: A group of cars/bikes move through
the city with lots of symbols, posters, and noise. Used,
for example, by the Blue Buckets movement in Russia to
protest the unnecessarily frequent use of flashing lights and
roadblocks by motorcades and vehicles carrying top officials.

repainting: In 1991, Czech sculptor David Černý painted a Soviet
IS-2 tank pink.

replacing: Swapping "normal" mannequins in shop windows with
"abnormal" mannequins.

shopdropping: Covertly placing your own items in stores.

refusing to accept management's absurd orders and laughing in
response to them

laughing in response to abuse by police or guards

laughing to protest a trial

(Ridiculing power is one of the best means of democratization; we
call it methods of laughter.)

(add your own items to the list)

To spark people's lives with meaning, art should not exist only in the form of an art market, as it mostly does now. A market—by definition—creates exclusive, not inclusive, experiences. Art belongs to everybody. We should be able to create more art in the street, in public spaces. We should have free communal art centers, where anybody who'd like to can create an artwork. You say that it's a utopia, I say look at Sweden in the 1980s and '90s. They had communal cultural hubs, where every person who walked in could learn how to, let's say, play the guitar.

EXHIBIT B: 2023 DESCRIPTION FROM PUSSY RIOT

On March 29, 2023, Meduza and AP reported that Nadya Tolokonnikova was added to Russia's federal wanted list. She is being charged under a law that was created in the aftermath of Pussy Riot's 2012 art piece, *A Punk Prayer*. The law deals specifically with "hurting the religious feelings" of people in Russia. In 2012, Tolokonnikova was charged with "hooliganism." However, the courts wished to broaden their ability to prosecute cases like this, so they created the "religious feelings" law, or the "Pussy Riot Law," as it came to be known.

EXHIBIT C: PUSSY RIOT STORMS INDIANA SUPREME COURT: "GOD SAVE AB*RTION"

This post features a video of a group of performance artists in pink balaclavas (decorated with ornamental small black crosses), black lace slip dresses, pearl necklaces, black shoes, long gloves, and black shoes flanking a ten-foot-tall inflatable vagina with canisters releasing plumes of hot pink smoke. The soundtrack? The new Pussy Riot song, "God Save Abortion," featuring Tolokonnikova. Nadya also hosted an event for faculty and students at Indiana University in conjunction with the protest.

November 14, 2023 @nadya Instagram post:

*Indiana was the first state to outlaw most ab*rtions after Roe v. Wade was overturned.*
*The state supreme courts have become the hand and uncontested voice of god, we protest this by paying homage to Martin Luther and delivering our theses—starting with Thesis Nº1, GOD SAVE ABORTI*N.*

OUR DEMANDS:

1. We demand the separation [of] church and state.
2. We demand access to LEGAL and SAFE abortion for every person in the United States.
3. We demand limitations of government control over our bodies.
4. We demand a Pussy Riot representative to be appointed as an official advisor to each state's supreme court, as experts on bodily autonomy.

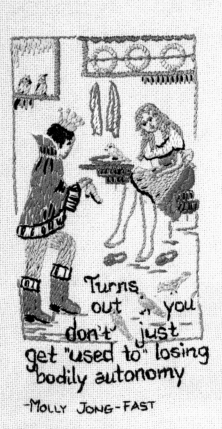

Turns
out you
don't just
get "used to" losing
bodily autonomy

-MOLLY JONG-FAST

DW

LIKE CRAFT FOR CHOCOLATE

FURIOUS VULVAS

LAGUSTA YEARWOOD
Chocolatier

Part of having a craft-based practice is being crafty with language, meaning, and medium. As I was curating this book, I wanted to find a perfectly subversive craft about unexpected pleasure. As the loss of and threat to a woman's bodily autonomy, health-care options, and right to choose have become a bitter bill to swallow, here's a little salty sweetness. (No matter the occasion, you can't go wrong with a sexy vegan treat.) Lagusta Yearwood is a restless, rabble-rousing chef-turned-chocolatier and the author of Sweet + Salty: The Art of Vegan Chocolates, Truffles, Caramels, and More from Lagusta's Luscious. *She is also the founder of Lagusta's Luscious, the first vegan chocolate shop in the world. Crafts like this remind me that there are a variety of tactics and approaches to political issues. A purpose of a craft-based practice is to be able to enter into difficult conversations around a common, pleasant activity.*

I STARTED MAKING THESE CHOCOLATES when George W. Bush was elected and haven't stopped. They're a delicious way to express my constant outrage that a woman's right to bodily autonomy is so often based on laws made by men. We talk a lot at our shop about how not all women have vulvas and not everyone with a vulva is a woman, but everyone can be angry about violations of basic human rights. With this recipe, you can re-create these chocolates to enjoy them on your own, give them to a friend, or sell them at a bake sale to raise money for abortion access funds. I hope they serve as a sweet reminder of a woman's right to choose.

FURIOUS VULVAS

Makes 10–100 vulvas, depending on the size of the mold

INGREDIENTS

¾ teaspoon pink Hawaiian alaea sea salt; honestly, any flaky high-quality sea salt will work! If you use table salt, use ½ teaspoon and add more to taste.

1 scant tablespoon pink peppercorns

1 pound dark chocolate (Make sure it's a high-quality chocolate sourced in ethical ways! We use 65% Republica del Cacao and we love it.)

EQUIPMENT

A vulva mold (see below)

A spatula, preferably an offset spatula

A parchment-lined sheet pan

DIRECTIONS

1. Procure your vulva molds! You can find an abundance of vulva molds online. Searching for "vagina chocolate mold" (even though I know you know that the vagina is the internal genitalia and the vulva is

the exterior!) will yield the most results. You can also DIY a food-safe mold by following tutorials online to make silicone molds from clay "positives." Depending on the size of your mold, you'll probably want to make or buy more than three at a time.

2. In a spice grinder, a mortar and pestle, or on a cutting board with a rolling pin or other heavy object, grind the sea salt and peppercorns until they're a bit smaller. Don't powder them, leave them a little chunky.

3. Temper your chocolate! The easiest way is to microwave ¾ of your chocolate on very, very low power until it's barely melted. Then grate the last ¼ of the chocolate and stir it in at the end.

4. Working quickly, mix the salt and pepper into the chocolate and pour the mix into your molds. Use an offset spatula to spread it neatly into every cavity. Pour any leftover chocolate onto the sheet pan lined with parchment paper.

5. Let chocolates set up about ½ hour at cool room temperature, then turn out of molds and eat! The leftover chocolate on the tray can be gently melted and put back into the molds or eaten as is.

6. If you want, you can package your Furious Vulvas in candy cups and candy boxes with ribbons and bows and give them away as gifts. Stored at cool room temperature, they should last six months or more.

CREATING AND CURATING
YOUR OWN
ART GALLERY

DANIELLE KRYSA

Artist, Creator of *The Jealous Curator*

Danielle Krysa, Canadian artist, is the curator of The Jealous Curator *contemporary art blog and host of the* Art for Your Ear *podcast. Her books include* How to Spot an Artist; Creative Block; Collage; *and* Your Inner Critic Is a Big Jerk. *In 2009, Danielle transformed the toxic jealousy she felt for other artists by blogging admiring posts about their work. By focusing on what she loved about their work, she found hers! You can see from the project she offers below that she's transformed her desire to own a gallery into a charming project for you. She believes in owning your complicated feelings about art, being on "nodding" terms with your inner critic, and creating community around the making of art. And she's pretty cheeky for a Canadian! She made a piece for* Tiny Pricks Project

of the Google search "MOVE TO CANADA" (the most googled phrase after the first presidential debate that fall) in October 2020 against the backdrop of a picture of the Rocky Mountains. I also stitched a quote of hers that I love: "Making art is such a vulnerable experience—that art only exists because _you_ exist." She's made art and being an artist more user-friendly, less intimidating, and more fun. While fostering a healthy, supportive community around the practice of making art, she has never lost her own rigor or process. Do not be fooled by her Canadian charm: she plunges the depths of the creative process with brutal honesty. She goes low and goes high. She does it all. And now you too can take a dose of the Krysa sugar to sweeten some of life's bitter medicine and have your own art gallery!

I'VE ALWAYS WANTED to have my own art gallery—so I made my dream come true on the side of the road in my tiny Canadian town! The grand opening of the OKMoMA—the Okanagan Museum of Modern Art—took place in the spring of 2021. Now, with this particular gallery, I really have to take the elements into consideration. For example, in the summer we had a heat-activated artwork (i.e., crayons melting in the blazing sun); the autumn show was a group exhibition featuring drawings of local apples; and last year's snowy holiday season kicked off with a light installation that came on as the sun went down. It has been such a joy-filled endeavor, not only for me, but for my neighbors and visitors alike! If there's a cause you're passionate about, you could also make that a focus of your mini museum. Maybe it's a hand-drawn portrait of your favorite activist, or a mixed-media collage of newspaper headlines—feel free to get creative. Think of this as an opportunity to bring awareness to whatever issues you care about.

MINI MUSEUM PROJECT, CANADA

MATERIALS

Old cupboard or cabinet, or a prefab "Free Library" kit

Scrap wood, metal letters, and hinges to create signage

A wooden post and post hardware to anchor into the ground

A tiny lock (if you choose to have a "security system" on your art museum)

Small easels from a craft dollar store

DIRECTIONS

This step-by-step is really up to you! You could make your gallery out of an old cabinet from the thrift shop, build it yourself from scrap lumber, or do what I did—I bought mine as a prefab "Free Library" on Etsy and then just painted it when it arrived.

Come up with a name for your gallery and then make some signage! I made my little museum sign with a scrap piece of wood that I painted white, and then glued on metal letters from the hardware store.

Once it's put together in a way that makes you happy, simply fill your neighborhood museum with art (hanging on the walls or sitting on tiny easels). You can show FREE ART that passersby are welcome to take, or perhaps a "Take Some Art/Leave Some Art" model. If you're an artist yourself, perhaps you show solely your work, or you could fill it with work by artists from your city. For my mini museum, I like to reach out to artists from all over the globe and ask them to share their work with my tiny town. Don't worry, I always make sure to invite them with this very honest disclaimer: Your work may or may not face the natural elements in Canada, and I can't guarantee it won't be stolen. Just sayin'.

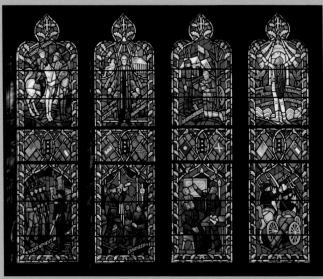

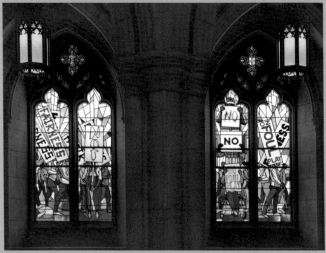

CRAFTING

LIGHT WITH STAINED GLASS

WASHINGTON NATIONAL CATHEDRAL WINDOWS

KERRY JAMES MARSHALL

Artist

Part of crafting a better world is recrafting narratives, art, public monuments, and institutions when confronted with injustice, racism, and dehumanization. In 2023, Washington National Cathedral unveiled its new racial justice–themed stained-glass windows titled "Now and Forever," created by world-renowned artist Kerry James Marshall to replace windows that honored Confederate generals Robert E. Lee and Thomas "Stonewall" Jackson, which were removed in 2017.

Now and Forever, *the book about this project, is dedicated to the nine souls who were taken at Mother Emanuel AME Church in Charleston, South Carolina, on June 17, 2015. Their deaths shocked a nation and awakened the conscience of a cathedral. Marshall said, at an event marking this new chapter in the cathedral's history, "Even the God of the Cathedral didn't have a permanent remedy against the evils that humans seem destined to inflict on one another. Today's event has been organized to highlight one instance where a change of symbolism is meant to repair a breach of America's creation promise of liberty and justice for all, and to reinforce those ideals and aspirations embodied in the Cathedral's structure and its mission to remind us that we can be better, and do better, than we did yesterday, today."*

The new windows celebrate the Black experience and protest for social justice. Marshall, whose work sells for millions of dollars, asked that his fee for the commission be $18.65 to signify 1865, the symbolic end of slavery in the United States. The last line of Elizabeth Alexander's poem "American Song," displayed beneath Marshall's new window installation, is "May this portal be where the light comes in." In collaboration with Kent State University's Wick Poetry Center, the cathedral also hosted an interactive "maker space" focused on the new windows, where visitors are invited to contribute a community poem.

All these art and craft interventions are designed to stimulate discussion, encourage reflection, and nurture inclusivity. If you're not able to visit the National Cathedral in person, you're invited to engage with art in your own community by following the activity below.

VISIO DIVINA MEDITATION

BY TERRI SIMPSON

Center for Prayer and Pilgrimage Program Coordinator

The iconography of Washington National Cathedral was created to instruct and inspire, to depict stories of faith and our nation's history while also inviting us to reflect on how we personally connect with those narratives. Part of our mission at the Cathedral Center for Prayer and Pilgrimage is to offer visitors contemplative ways to engage with the art and architecture of the building.

Visio Divina, or holy seeing, is one of the foundational spiritual practices we teach. Derived from the monastic practice of Lectio Divina, it comprises a simple rhythm of looking at an image, such as the Now and Forever windows, and moving through a process of reading, reflection, and commitment to action in our lives. While the iconography of the cathedral is literally written in stone (and glass), Visio Divina encourages us to approach the stories over and over again with fresh eyes as we view them through the lens of our particular contexts in the moment of meditation.

THE PRACTICE

LOOK (VISIO)

Take some time to look at the image as a whole. What do you see? What is the literal depiction shown in the work? Notice the figures, words, colors, shapes. As you let your eyes move around the image, begin to notice what energy and emotions you are seeing in the image.

REFLECT (MEDITATIO)

Continue to look at the image. Is there a particular figure, a small detail, or hue your eye returns to, something that keeps drawing you back to

look at it again? When you find this detail, take some time to notice the energy and emotions that you are feeling in your own body. What associations, memories, or connections is the image bringing up for you? Is it shining a light on a situation in your life or in the world at this moment in time? Spend a few minutes reflecting on the wisdom the image is offering you today.

RESPOND (ORATIO)

After your time of reflection, consider how you will respond to seeing this image. Is there an invitation to further thought, action, or change that has arisen for you? You might want to draw upon your own creativity and express your response to the art through poetry, art, movement, or music.

BE (CONTEMPLATIO)

After you have finished your close looking and response, return to the image. Expand your field of vision once more and soften your gaze as you look at the image for a final time, simply being with the story and the experience.

ACT (ACTIO)

As you return to your rhythm of daily life, be aware of moments when you can act upon the invitation you received during your practice of Visio Divina.

CRAFTING

A WEB OF WORDS

CHARLOTTE CLYMER
Activist

Charlotte Clymer's biography on her blog, Charlotte's Web Thoughts, *reads: "Politics, religion, culture, and humor from a Christian trans woman. 2023 and 2024 GLAAD Media Award Finalist for Outstanding Blog." The bio on her Instagram reads: "Writer. Lesbian. Army Vet. Texan. Hoya. Perpetual." She is super "web-worthy" and brings a lot of creativity to her posts. When she tweeted about the then recently fired Tucker Carlson, "I'll be very disappointed if Tucker Carlson's fans don't blame trans people for this. We want credit," I had to stitch it for* Tiny Pricks Project. *It had the perfect balance of Clymer wit and humor along with a twist on the expected "Don't blame trans people" disclaimer. If E. B. White's Charlotte knew about the power of words to uplift a potentially*

doomed pig, this Charlotte knows the power of words to uplift a potentially doomed democracy. Her blog, like Wilbur, is terrific, radiant, and humble. Some blog! She's a wonderful example of how to make current political discourse better by being firm and funny (and that's a crafty business!). Tweet or thread, she focuses on kindness, on keeping dialogue open, and on compassion. For a recent birthday, she asked people to make a donation to Running Start, a nonpartisan nonprofit that trains young women to run for political office. In her own words, here's an invitation from Charlotte to run with uncomfortable feelings as we engage in activism.

I'VE SPENT MOST OF MY ADULT LIFE involved in some form of social and political advocacy, and I can offer up two things I've learned beyond the shadow of a doubt.

The first is that I know less now than I did when I started this work years ago. Growth is a long process of patient unlearning, which uncomfortably demands humility.

The second is that when you're on the wrong path, discomfort can guide you to the right one. Discomfort is a free gift. This is just as true for any part of life as it is for activism.

Discomfort, oddly enough, is the surest signal we have that something needs to be improved within ourselves. That incongruence between

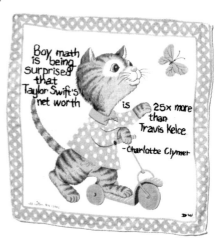

Boy math is being surprised that Taylor Swift's net worth is 25x more than Travis Kelce

—Charlotte Clymer

expectation and reality creates a point of friction, and there's a rather savvy part of us inside that lets us know to focus on it. It can be painful, sure, but it's remarkably accurate. Not all discomfort is healthy, obviously, but there are moments, particularly in our journey of allyship, when we're reminded of how little we know. Or embarrassingly, when we're reminded, even with the best of

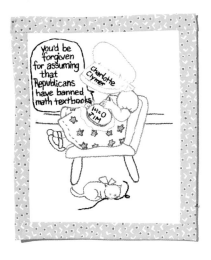

intentions, how easy it is for us to not know. And most tellingly, when we're certain we do know when we really don't.

We live in a time of towering uncertainty. Another election looms on the horizon, our societal fabric seems increasingly strained with each passing day, and far beyond that—though unsettlingly close—is what to do about this planet we all live on together.

I am willing to make a promise to anyone, and I'll bet every nickel in my pocket against every nickel in theirs that it will come true. Are you ready? There's gonna be a time in the not so far off future when we all long for the snapshots of unlearning that we may not have paid attention to earlier in our lives because they were too uncomfortable to negotiate. Don't fear those moments. Learn to savor them. Step inside that discomfort for a bit and walk around with it. Your brain is trying to tell you something, and if you're willing to hold out past the initial frustration and discomfort, there's often worthwhile clarity on the other side.

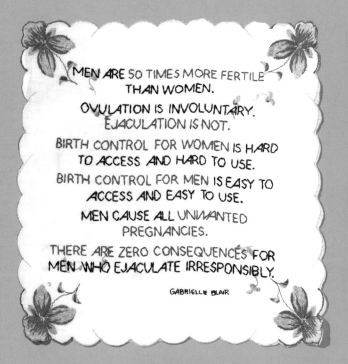

CRAFTING A
NEW
ARGUMENT

AN INTERVIEW WITH GABRIELLE BLAIR
Designer, Author

Gabrielle Blair, @designmom on social media, is a mother of six, a Mormon, community organizer, entrepreneur, and designer. When the reality of the overturning of Roe v. Wade hit, she decided to take a new approach to the well-established divide between men and women when it comes to responsibility for unwanted pregnancies. Her book, Ejaculate Responsibly, is a well-crafted argument designed around the science, dignity, and practicalities of the debate around abortion. Just as she renovates an old, dilapidated house with an eye to preservation and improvement, her book offers a refreshingly new, inclusive, and organic conversation about abortion, bodily autonomy, and health care.

A creative approach to political issues is essential to reshaping current political discourse. If based in fact, it can be one of the best arrows in one's activism quiver. Before we act on our concerns about an issue, it can be very helpful to take a fresh look at it. Gabrielle's activism, the publication of her book, is a good example of how to communicate information in an accessible, fun, and effective way. I also appreciate her intergenerational, public-facing approach to activism.

Gabrielle took a break from meticulously renovating a home from the 1600s in France, to answer my questions about the process of crafting her forward-looking book. Craftivism can be based on political action with a destination. Her book campaign is a good example of one that fits well with craftivism values: thoughtful, quiet, subversive, impactful, unusual, nontraditional uses of existing systems to encourage new ways of thinking and acting.

DIANA: It's always bothered me that abortion is such an important topic for everyone, and yet most of the abortion activists I know are women. I've had two lifesaving abortions because I had two ectopic pregnancies. I was able to safely and swiftly abort pregnancies without guilt, shame, harassment, and legal obstacles. It's only a matter of life and death for those who can give birth. It seems like you had a mini epiphany when you realized a lot of men don't really care about abortion, but care about the politics around abortion. Is it the case that once you saw it this way, there was no way to unsee it?

GABRIELLE: Yes, it really came to a head for me during the Kavanaugh hearings. It was man after man after man grandstanding about how important it was to limit abortions and every single talking point only pointed at women and what they should or shouldn't be allowed to do with a pregnancy, and no one ever tried to connect

the dots about how an unwanted pregnancy occurs. Or preventing unwanted pregnancy did come up, but the men continued to point only to the woman, and how she should have kept her legs closed. Meanwhile, if men really, truly cared about the topic of abortion, they could immediately prevent them by preventing the cause: irresponsible ejaculations—which is when a man deposits sperm in a vagina when the couple is not trying to conceive. It is not asking a lot for men to avoid this.

DIANA: I am now of the age when I don't have to worry about getting pregnant. It's very liberating! And yet I lived with that anxiety for decades. I love that you have introduced the burden of responsibility to men. Were you excited to bring men into the discussion in a new way? Has *Ejaculate Responsibly* brought men and women closer together over this issue? (I hope so!) Do you think it has opened the door for more pleasure and less worry in general around sex?

GABRIELLE: My husband got a vasectomy several years before I wrote the Twitter thread [that inspired my book], and it was absolutely a game changer. I just have anecdotal evidence, but I would say a resounding YES to all these questions. I have received so many messages from men who exclaim that after reading the book, it felt like their eyes were finally opened, and they couldn't believe they were blind to this their whole life. And the book has been a very helpful tool for women to broach this topic with their partners—much more than a couple of talking points could, or even the Twitter thread. Reframing the issues in this way has been eye-opening for women too—it was eye-opening for me as well when I first connected the dots. When people have better information, for the most part they behave better. Years ago, I remember researching and being surprised by the number of abortions in the United States. It was a higher number than I would

have guessed. But when I started to work backward to try to see why or how this could be, the high number made total sense to me.

For the book, I did the research to really establish the arguments, but before it was a book, it was a thought experiment, and for the initial thought experiment, first I asked: Why wouldn't the woman be using birth control? I'm embarrassed now that this was my first thought as I worked through the questions, and yet this is still the conventional response to preventing unwanted pregnancies: for the woman to carry the full burden of pregnancy prevention work. As I considered that question, I thought through what it meant for a woman to get birth control, relying especially on my own personal experience and frustration with this process—finding a doctor who works with your insurance, having to wait weeks for that appointment, getting childcare for the appointment or getting off work (or both), figuring out transportation and parking, enduring a highly invasive physical exam, filling a prescription, paying the costs of the doctor appointment and prescription, being responsible for daily maintenance (if we're talking about the pill), dealing with side effects, and doing this for years and years whether or not you currently have a sexual partner.

Instantly, the answer to why a woman may not be using birth control seemed very obvious. And then, when I considered what birth control for men looked like—basically, condoms or a vasectomy—and how accessible and affordable and effective and simple the options were, it was not so much a light going off as it was a sort of duh! realization.

On the question of increasing pleasure in general around sex, I would say that this book has made it easy to speak in realistic and practical terms about this enormous burden, this elephant that has been in the room for sexual relationships—the woman exclusively

carrying the entire burden of pregnancy prevention work. Once everyone recognizes this and we can talk plainly about options to reduce or eliminate this burden, it can feel a lot like freedom. The pleasure can easily increase when the burden and stress around pregnancy prevention is decreased.

DIANA: Can you talk a little about the role art, design, and material elements have played in your project in terms of communicating your message?

GABRIELLE: The book design was done by the acclaimed Bonnie Siegler, and I'm so lucky that I got to work with her. Her design absolutely elevated the book and makes it stand out anywhere. It's a design you want to pick up and examine, and the retro feel lends it historical authenticity.

I really love the title of the book because it captures in two words (ejaculate responsibly) the entire solution, and it gives a call to action at the same time! It truly is a simple message, and I want to normalize it—and the design is a tremendous help in that. The Ejaculate Responsibly tote bag and I ❤ Vasectomies hat and other merch are beautiful and fun even without the messaging, and the messaging is powerful even without the beautiful design. But together, I think it definitely makes it easy for anyone to share and promote and help normalize this key message: that so much gets resolved if men just ejaculate responsibly.

DIANA: Writing a book can be a radical act, but it occurs to me that your book is a triple threat: there is the content, the way it is written on the page, and then there is what you did with that small but mighty book. Can you share with us what you did to market it, the way you mobilized readers to send copies to governors, Supreme Court justices, and senators after *Roe* was overturned, and the ways

and places in which you got the conversation rolling? And the tracking of books?

GABRIELLE: Yes, the hope was always to make the book easy to read, easy to follow, and have clear and simple actions to take. I know it is an audacious book, but I have seen and read hundreds of times how the arguments have profoundly shifted people's understanding and perspectives for the better. The first, most important step for me was to make sure that the book worked in that sense—that after someone read it, they would see these connections and change their perspectives and behavior accordingly. This meant really refining and crystallizing the arguments and effectively addressing counterarguments without making the book into a tome. The arguments are strong, and the book is very effective at shifting people's perspectives, and has the possibility to shift our national and global discourse around these issues.

When I felt confident about the effectiveness of the book—and I had good reason to be confident, from reviews, and from the years I had engaged with people on the original Twitter thread—then the effort turned to extending the reach and getting the book into the hands of people who could make a difference. This is an ongoing effort. The book hasn't yet had nearly the reach it needs. But our first efforts were to try to help readers visualize the impact of the book.

When they could send a copy to a Supreme Court justice, or a senator, or a governor, and they could also see how many copies had been sent to these people, this helped readers imagine the impact of the book and, I hope, imagine the prospect of a future where the arguments and insights from the book are just taken for granted, which I think can be a beautiful image of a much healthier future.

DIANA: You seem to sometimes lead with your faith-based identity. I assume that this is a deliberate choice and has an impact. Faith-based activism is interesting to people, especially around a topic like abortion. Do you think there will ever be a shift in faith-based anti-abortion communities around abortion? About speaking out?

GABRIELLE: You're right that this was a deliberate choice. The topic of abortion has been so polarizing for so long that often people will only listen if they believe someone already agrees with them. Invoking my faith identity, together with my claim that politicians don't actually care about reducing abortion, was a sort of dog whistle for the audiences I wanted to reach. I wanted to convey something like "Hey, you can trust this voice" to everyone. And for the most part, it has worked.

It's still really difficult to imagine a major shift in faith-based communities around abortion, but anecdotally, based on responses I have seen to my book, I do have a lot of reason to hope. I don't imagine faith-based anti-abortion communities will do a 180 and advocate for something like a return to *Roe*. But I have seen many people in these communities reframe the issue in terms of reducing abortions by reducing unwanted pregnancies by reducing irresponsible ejaculations. This is extremely encouraging to me because it shifts the conversation away from abortion to prevention and shifts the arguments away from trying to control women's bodies.

DIANA: This is a hard topic, but it's important. I heard you talk somewhere about the violent reaction a man had when asked to wear a condom. Can you say a little more about this, and how bringing this subject out into the open can actually prevent further violence?

GABRIELLE: Yes, it makes me sick that any man would do this. Not being able to bring up condoms out of fear of such possible

reactions is discouraging, disheartening, and infuriating. But I think there is actually a practical solution. When these topics aren't widely, widely out in the open, such conversations are private and subject to particular relationship dynamics. The solution is to talk about this much more widely, much more systematically.

The example I return to is how we as a culture shifted our expectations around wearing seat belts. When I was a teenager, seat-belt laws were being instituted, and I remember thinking that seat belts were so silly and thought no one would ever wear them. Then there were massive advertising campaigns and many discussions and news stories with data and experts and personal stories about seat belts. What made the difference for me was when the cool kids from the big city visited my hometown for spring break, and we were going to go for a drive, but they wouldn't start the car until everyone was buckled in. My teenage brain had an immediate shift (Oh! The cool kids wear seat belts? Okay, then.), and I have never questioned seat belts since. And tellingly, seat belts have become such a cultural norm that my children have never, ever questioned wearing seat belts.

I want to see the same type of cultural shift happen about responsible ejaculation. I want to see condoms and vasectomies be commonplace and expected. I want to see fact-based sex ed programs. I want to see widespread free and accessible birth control programs. I want research dollars to be spent on more pregnancy prevention options. I hope my book can play a part in making that cultural shift happen.

DIANA: Your book really helped me see that it's better to make rational arguments than to make angry ones. I really admire the fact that your book is an invitation. How did you come to this approach to activism?

GABRIELLE: I definitely started angry. And I am still angry about the issues in the book. And I've done a whole lot of yelling on Twitter, so I wouldn't say that I have just always and consistently taken a rational approach.

I will say that my anger has been an important motivator to research and look deeper. In that sense, my anger has been practical. And I know that while taking an angrier tone would have been satisfying in some ways, it would be counterproductive to the ultimate aims of the book, which, as audacious as it may sound, really are to shift our culture to promote more responsible behaviors, especially for ejaculating men.

CRAFTING!
CURATING!
COSTUMES!

A STAR IS BORN

REBECCA SEAVER
Creative+Production+Design+Nashville

Rebecca Seaver is a creative force for good. They are the curator of
Dolly Parton's extensive costume collection (think six decades' worth of
dresses, wigs, shoes, and accessories), a coauthor of Behind the Seams:
My Life in Rhinestones, and founder of the Rhinestone Cabaret. Rebecca
oozes creativity from the tips of their acrylic nails. I'm fascinated by
their amazing costumes, performance art, sense of family history, and
overwhelming pride in their making.

Rebecca invites you to take a risk and, as their friend and cabaret
phenomenon Scotty the Blue Bunny says, "Embrace the suck" (just
as they did when starting burlesque about a decade ago). In their
world, obstacles such as age, preconceptions about body image, and
inexperience don't have to stop you from following your dreams. Don't
wait to be perfect. Even if it seems crazy. Do what you want to do.
Especially if you're scared. After all, Rebecca's aunt and boss is Dolly

Parton, an icon of self-determination, creative rigor, and reinvention. Rebecca comes from a long matrilineal line of spirited, strong trailblazers who honor their musical roots while reaching for the stars.

Dancing out of their comfort zone, Rebecca took to the stage with dazzling fans, feathers, tassels, corsets, and gloves: first in 2008 as a burlesque dancer named Truvy Trollop, and now as a drag performer named Mx.Mona Von Holler. Both names were inspired by Dolly's movie characters—Truvy from Steel Magnolias and Mona from Best Little Whorehouse in Texas.

With the weight of the Tennessee drag ban, they feel it's important to destigmatize draglesque (drag + burlesque) and celebrate an art form that combines their family history in music and costume while also advocating for bodily autonomy, the decriminalization of sex work, and LGBTQ+ rights.

Rebecca is a history buff, and every costume carries a story; the beads, sequins, and stitches are mark-making and the cloth is the page. See page 134:

> This is the first costume I made when I started performing again after the pandemic. All the appliqué I used on this were made from remnants of fabric Dolly had an outfit made of. Her designer let me have a bit of the leftovers and I created my thing from it.
> —MX.MONA VON HOLLER, PHOTOGRAPHED AT THE BRASS STABLES, PRINTER'S ALLEY, IN NASHVILLE'S HISTORIC DISTRICT

I want to share with you an important aspect of crafting that I've found essential to my work: posting on social media. We are surrounded by tools that capture, curate, control, and create our content. Our stories unfold before unseen eyes. Most of us create because we want to share our work and connect with others. Craftivism, art, and activism all

require an audience to be fully realized. But how to do it on our own terms? Below is an example from Mx.Mona of how to use language as a storytelling tool. Putting our art into works is a way of ensuring that it, and we, have some control over the context in which we are creating and can more effectively get our messages across. As you can see, Mx.Mona packs in a lot of information while being intimate and informal. Even the use of emojis has become a craft of sorts!

@therhinestone.cabaret, Mx.Mona Von Holler, June 3, 2023, posting pride:
I'm just so proud to be QUEER. Happy Pride y'all . . . what a riot it's been already‼ Drag is legal in TN! Boom! With that, burlesque, gogo and other underground art forms are safe once again!

As a paaaaaan-sexual, gender-queer, DRAGLESQUE artist I want to encourage you to follow your dreams no matter how bizarre and outlandish they are. I also want you to remember that your dreams are allowed to evolve and you don't have to want the same things you wanted at 15. Success comes in so many forms. Your path is beautiful in its uniqueness to you! Go forth and shine my beauty babies.

I want to thank everyone who has supported me in my new journey as Mx.Mona! It means the world to me to hear you saying my name, cheering on this new exploration, and feeling your support. Thank you to everyone that has given me performance opportunities and the chance to grow in this art form. I am JUST GETTING STARTED‼ I can't wait for what the next year holds.

Keep it slutty, keep it queer, and remember, JESUS SAVES BUT MX.MONA DELIVERS‼

I love you all the MOIST!

Real change, enduring change, happens one step at a time.

CHALLENGING TIMES,

CREATIVE MEASURES

TINY PRICKS PROJECT

DIANA WEYMAR

You're invited to join Tiny Pricks Project *by making a political protest piece to donate to the permanent collection of over five thousand exhibition textiles or, by using the same technique, to make a personal piece to keep for yourself or give to a loved one. Whatever you're feeling the need for, whether it's rage, rest, restoration, or repair, this project is a way to needle your needs into something beautiful.*

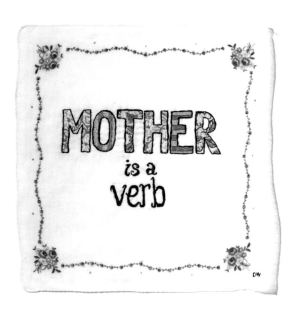

TEXTILE CONTEXT: Find a textile to be your canvas. I work primarily with vintage hankies, but when the creative spirit calls, I dabble in small doll clothing, tea towels, family memory materials, and found needlepoint. If you don't have any of these items at hand, your local thrift store is full of treasures, and the internet presents endless options. When considering a textile, think about the amount of clear, available space without a dominant pattern, its thickness, and the way it makes you feel when you look at it. Textiles are visual tools that contain memory triggers, offer comfort, and give us cultural context. They live close to and with the body. As you create a new artifact, consider the language of your selection. What will it say about the moment you're in? About you?

TOOLS: Textile, water erasable fabric marker (I use the Leonis brand), cotton embroidery floss, scissors, paper, pen, embroidery needle, and hoop.

YOUR TEXT: What words speak to you? As you can see from my Instagram account, I find source text from all different places: current political discourse, writers, artists, musicians, podcasts, poets, and my personal life. If it's a protest piece, I find text that stands out to me as especially emblematic of a certain issue or moment. What does it say about our society, government, and values? Or do I just find it plain offensive and need to stitch it because I'm pissed? If it's a personal piece, I work with text that captures my emotional state, resonates long after I've read it, might reach or help someone else, and inspires my practice. As a contemporary version of a traditional American

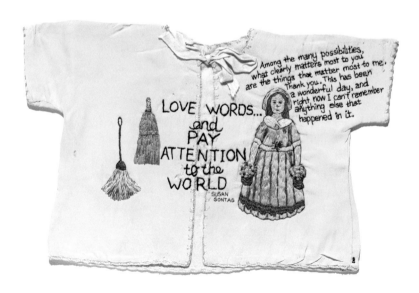

sampler, your piece contains elements of autobiography, journaling, and storytelling. This is who I am. This is what is important to me. These words tell you what I think, and how I stitch them is how I feel. Whatever your choice of text is, remember that there is always an element of the subversive to this medium: don't be afraid to play with the traditional, gendered expectations around this practice. You're not a quiet, submissive person with your head bent over your piece, sitting in a wooden rocking chair. You are crafting art, you are here in this moment, and what you make matters. You matter. Find language that makes you feel powerful.

MAPPING IT OUT: The next step is to transcribe your text onto the textile. You may map out your text on a piece of paper the same size as the available space on the textile to check for spacing, font, and size.

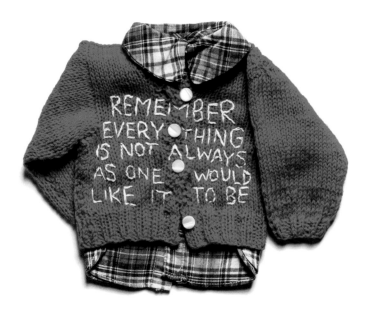

I go straight to the textile but use a ruler and fabric marker to make straight lines and then write out the text in the available space. As a general rule, I keep the font size large enough that it's easy to read on social media. Another consideration when selecting font is your available time. Cursive takes longer. The more loops and curves in your font, the more stitches it takes to create. Creative arrangements of the text can contain "hidden" meanings. Play around. You want your text to have some sort of personality to differentiate it from machine embroidery. I think of it as keeping the hand visible in the handiwork. Character. If you want perfection, buy a machine. If you want humanity, give it your personal touch.

THREADING THE NEEDLE: GIYF (Google is your friend). If you don't have someone in your life to share their knowledge with you and you're a beginner, I suggest googling the following: using an embroidery hoop, threading a needle, and basic sewing stitches. I've developed preferences over the years: a tight hoop (the fabric taut like the surface of a drum), black thread (three strands—separate the original six in half, so that there are three strands in each "thread"), a knot at one end and a loose "tail" (as opposed to doubling the thread back and knotting the ends together), a simplified script font with a few printed letters, and hankies folded twice with the design in the lower right corner.

STITCH BY STITCH: When you're ready to start stitching, my considerations shift from the task in my hands to my environment and intentions for this time. This is your time with others or yourself. Are you comfortable? Do you have a beverage? Good posture? A show to watch or a podcast to listen to? Are you stealing time while keeping someone company or doing something else? I've been known to stitch while traveling, in the bathtub (don't let the thread get wet or it will erase your text!), in coffee shops, while catching up on phone calls, at the beach, and especially while watching the news or political debates. I carry several pieces around with me in my bag at all times. You never know when you might have to wait for an appointment or for a friend! I've stopped short of wearing a T-shirt that says "I'd rather be stitching," but . . . Some of my best ideas come to me while I am stitching, so I often keep a notebook or my phone nearby. This is a time to experiment and see what you can make, learn, and produce in the process. It's not about getting something "perfect" or impressing someone else. It's your time and your work.

CLOSING THE LOOP: when you're finished forming the letters, tie a knot in your thread on the back side of your piece and take it out of the hoop. Soak it in a bowl of water for a few minutes to get out the marker, leave it to drip-dry, and then iron the back on high to medium heat, depending on the type and thickness of the textile. If you would like to donate your piece to my project, DM me on Instagram. If you're keeping it, send me a photo! I love seeing what people make. These are rough guidelines. There are dozens of tiny choices you're going to make along the way that make your piece unique.

Notes from a curator

Two ways to play it: safe or dangerous. Soul searching.
What's going to make you stronger? Your work stronger?
Slowing down the mind, working with hands. Push & pull.
Go where your heart is. Community, poetry in the darkness.
Don't worry about pleasing people. Tension felt all the time.
What are you equipped for? Huge sacrifices—family decisions
Listen & think about what people are saying to you.
When showing work, separate the decorative work from the rest.
Edit your own work—take out weak stuff. Don't talk about yourself.

POCKET SIZE
HEAD COVERING
FOR
Chapel & Church
Lace
Prayer Cap

AFTER MORE THAN A DECADE of a craft-based practice, I now recognize that inspiration comes to me in one of two ways: as a slowly building wave or as a sudden sharp prick. The former is an amalgamation of memory objects, emotions, experiences, outside influences, books I'm reading, places, photographs, events, time in nature, and former selves. It gathers momentum until it has enough energy to take off. The latter comes as a flash almost out of nowhere. It is sharp and impulsive. I know exactly what to do and how to do it. I can see it before it exists. Either way, once inspiration calls, it must be answered. It is impatient. It has to be realized, released as flow, connection, and creativity. I'm along for the ride. Now that you have a good sense of some of the creative people who inspire my world, I would like to share with you some of the stops on my creative journey inside and outside my studio.

It's always about the material. (In my case, sometimes literally!) Like a lot of the creatives in this book, I use personal material in my work. About a decade ago, I took an art course called Art and the Language of Craft to fulfill some prerequisites for a master's in art therapy. It was a kind of homecoming. Familiar and yet revelatory. The old made new. My maternal grandparents had passed away around the same time, and I inherited boxes of textiles: napkins, hankies, christening gowns, tiny wool sweaters, booties, baby dresses, mysterious textiles to cover breadbaskets or tissue boxes, and my grandmother's abandoned needlepoint projects. Personal textiles are imbued with ambiguous meaning. We sense our mortality relative to their materiality. I was the last stop for objects that had been preserved for generations. They were unfamiliar family treasures. Without a practical purpose, the function of these objects was to hold memory and tradition, and to preserve some sort of history. Unable to throw them out, donate or put them to daily use, I decided upon a fourth option for these pieces of my family history: creative material. I could use them in my art practice! (Sorry, Mom.) Sets of starched, monogrammed twin bed sheets became fabric pages for future projects. The little wool sweaters used for a series on the Ebola virus. In a sense, these textiles were getting a second life! I think we're all uncertain as to what materials will matter to future generations. The materiality and meaning of objects are shifting. We are transitioning to virtual experiences, away from the handmade, and to creative tools with an intelligence of their own. Bringing what was made before into new spaces (social media, virtual reality) is a way to integrate past histories and new technologies. *Tiny Pricks Project* would not exist without my family textiles, but it also would not exist without Instagram.

Beyond materials, there is a feeling about the making. I first experienced the pure joy of deep engagement in a creative project during the summer of 1994, when my best friend from high school and I drove an Isuzu Trooper packed with about two hundred Barbie dolls, a Super 8 camera, and a lot of pink plastic Barbie gear across the country to make a movie. We filmed in Las Vegas; Dollywood; Graceland; Truth or Consequences, New Mexico; Death Valley; Hollywood; San Francisco; Toronto; New York; and everywhere in between. We took our work and ourselves very seriously, but it was so much fun! Like the main character of our film, Barbie, we came from a small logging town in Northern British Columbia to big cities in search of fame, fortune, and, at the time, what we would have called something bigger. I have now come to recognize that "bigger" feeling as a sense of belonging through making. When the other, very big Barbie movie came out thirty years later, I could not help but reflect on our small Super 8 film, *Barbie: An American Biography*, and feel nostalgic for the fun we had together, the absolute faith we had in each other, and our relentless pursuit of creative adventure. We were making exactly what we wanted to be making. Making is a sense of being. Of self. I feel this still. This is what I know how to do. The rest of the world is a mystery. And that can be a good thing as well as a very hard thing.

In my studio work—as opposed to my public projects—I have taken an approach similar to that used when making a commonplace book. It's a personal compilation of knowledge (my own or someone else's), ideas, experiences, quotations, and observations. I'm convinced that if I collect enough good words, good writing, and good writers, I can counterbalance some of the bad stuff and ward off evil spirits. (Maybe even evil presidents!)

John McPhee is one of my favorite writers, so I decided to apply my needlecraft to his thoughts about the craft of writing. I turned my grandparents' pristine, heavily starched cotton bedsheets into "three-hole lined paper" by machine stitching a vertical pink line and horizontal blue lines. (I remember the early days of buying a back-to-school ream of paper, a hallmark of a new year of learning, so notepaper felt like a good way to honor a teacher!) Years later, when all ten pages were stitched, John saw them on exhibit and sent me this email:

> *Diana—Just now, at the end of the day, I stopped off at the Arts Council. After I had come upon the ten pieces, and, over the next minutes, absorbed what you had done, I was—thread and bedsheet—moved to tears. I thought, if she has done that, I am going to follow the thread from word to every word, which I did. I was moved by your imagination—that clock!!—and by your selection. Among the many possibilities, what clearly mattered most to you are things that matter most to me. Thank you, Diana. This has been a wonderful day, and right now I can't remember anything else that happened in it. John*

When I think back on the many hours spent making the *John McPhee Sampler*, it was worth every minute to get this email.

I've also translated other forms of information into textile and thread. The W. E. B. DuBois infographics especially caught my imagination as he had sought a way to process information about how the African diaspora in America was being held back in a tangible, contextualized form. I stitched ten pieces based on his infographics into textile form to further highlight his work. One of the beauties of thread is that while it speaks the language of lines, drawing, and

painting, it can also be manipulated to construct three-dimensional language. Over the past decade, I've collaborated with hundreds of writers, musicians, activists, and nonprofits to create tangible, vibrant forms of their work. I still haven't run out of material that I want to stitch! Sometimes I am so focused on the stitching that I have to remember to breathe! I've stitched through debates, car rides, movies, meals, doctor visits, train rides, and TV shows. If there is light and my hands are free, I am stitching. I am free in the moment so, in a way, I am completely present.

It's always felt important to me to work with people outside my studio on inclusive projects. I find working in parallel with others, when everyone has something to contribute, to be very stimulating. It's taken some practice to figure out how to do that with my craft.

My first public textile-based embroidery project was a complete failure! An organizer for a writers festival asked me to create a participatory project. My concept was that I would stitch a book

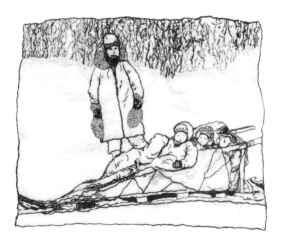

title for each of the twenty-plus festival writers before the event and then invite people to stitch into the banner responses to the prompt, "What is the connection between writing and memory?" At the event, I set up boxes of bright, colorful threads and all the supplies needed, plugged in an electric teakettle, and put out vintage teacups next to the 8' x 2' banner table at the event. People stopped to appreciate my work and then moved on. Hours went by before someone sat down to work on it. My first "guest" drew a bird with the fabric marker, threaded a needle, and started stitching. She was eight years old and only sat down at my table to stitch because she was tired of hearing her mother (a poet in the festival) read. Her confidence was extreme. She didn't let me help her once! Many people who had spoken with me that day expressed how nervous they were about "messing up" the work I had already done. The next day I left the banner and supplies on the table and went to all the readings. The poet Matt Radar, when speaking about teas that have fancy names, said "I drink a tea I call 'many years of reading,'" I immediately imagined a traditional fussy teacup with a teabag tag hanging off the edge with Matt's words on it: MANY YEARS OF READING. When the festival wrapped up, I went home and threaded a needle. I translated all my notes into text fragments and illustrations. I developed a thread language, learned how to sit still for long periods of time, and captured what mattered the most to the writers. I added more words by some of my favorite writers that I wished had been at the festival: Maira Kalman, Alice Munro, and Carol Shields. I also added things that I heard on NPR while stitching. Quotes from books I was reading. The banner is a material record of what I was reading, thinking, and listening to during that time. It is a reply to my own prompt about the connection between memory and reading.

OH, THE PLACES YOU'LL GO WITH YOUR CRAFT!

Over the past decade I've had opportunities to travel outside my studio, with textile, needle, and thread, to different parts of the world. For five years I attended Build Peace conferences in different countries as an advocate for the benefits of community-based art initiatives: Nicosia, Cyprus; Zurich, Switzerland; Bogotá, Colombia; Belfast, Northern Ireland; San Diego; and Tijuana, Mexico. These gatherings focused on the responses among peacebuilders to the ongoing challenges to peace in the digital era. Each location was a unique interdisciplinary space in which global issues around conflict resolutions and innovative practices were explored through discussion and workshops. Sitting around a table stitching brought people together by engaging in a predigital-era activity, and this was often the most intimate part of the conferences.

I created *Interwoven Stories*, an international public arts project made up of hundreds of pages, like the *John McPhee Sampler*, to allow for small, specific groups to come together to form a large art collection. What would people have in common? How would their pieces relate to each other? What defines community? To provide visual uniformity, I decided on the three-hole lined fabric sheets. Each participant was given a kit consisting of a fabric page, hoop, embroidery floss, water soluble fabric maker, and needle. With the help of a residency with the Arts Council of Princeton, I developed the project through workshops, demonstrations, and community outreach. Participants were invited to stitch their responses to a cultural mapping prompt about the importance of landmarks, common values, traditions, and beliefs as the guiding principles of community. The four hundred–plus *Interwoven Stories* pages come from more than eight different communities, ranging from an art

program for children in Damascus, Syria, to a group of trans and gender diverse teens in Victoria, British Columbia. When exhibited all together, the pages tell an intimate story of craftivism: each participant is seen as belonging to the collective.

THREADING ACTIVISM

We are called to pay attention to the world, but it's important to do it in a healthy way. With so much news, information, and misinformation at our fingertips, it can take time to process the emotional impact of the world today. The 2015 image of two-year-old Alan Kurdi's body, washed ashore after drowning in the Mediterranean in an attempt to escape the civil war in Syria, still haunts me. His tiny shoes with ribbed plastic soles were still on his feet. Your heart can break a thousand times before you've finished your morning cup of coffee if you are open to the world. And it should. But it can't stay broken.

Working with our hands to address the issues of our hearts can help. It's a physical process to make something, but it's also a processing of emotions. There are big worries and there are small worries. We carry both. A creative outlet can be one way to live in a world of endless information and input.

In my search for ways to engage in craftivism outside of domestic issues, I have found collaborators with whom I can explore ways to use thread and textile to reach new audiences and hopefully move the needle. In 2018, I collaborated with Mansour al-Omari, the Syrian journalist and activist, on *Names Disappearing: Your Story Will Be Told*. I first read about the five scraps of the textile, upon which the names of Syrian prisoners were written in blood and rust with a chicken bone that Mansour smuggled out of prison, when they were exhibited at the United States Holocaust Memorial Museum in Washington, DC.

Mansour wanted to raise awareness about the plight of tens of thousands of Syrians who have disappeared since President Bashar al-Assad stepped up his crackdown on his critics in 2011. Mansour and I created an object that would preserve the information contained on the fragile fabric scraps and that we could share with a wider audience.

For the textile, I selected a white cotton nightshirt inherited from my maternal grandparents. It resembled what I thought the original shirt might have looked like, and I changed it into a canvas by flattening and sewing shut the openings in the garment. The body is absent from the sealed garment, just as the prisoners are absent from the lives of their loved ones. Mansour shared four categories of documentation with me: full names of prisoners who have been released, those still imprisoned (first names only for security reasons), initials from each city or area from which detainees come, and a few phone numbers of detainees. A family gave us permission to use

a detainee's full name in Mansour's advocacy work. The bearers of these names suffered inhumane conditions because they spoke up for freedom and basic rights. Journalist Nabil al-Sharbaji, whose name is mentioned in full on the shirt, was killed in Sednaya Prison in 2015. Mansour's hope was that if his story was told, it would be repeated to others and live on in the telling. This piece represents only a tiny fraction of the thousands of enforced disappearances in Syria since the beginning of the uprising.

In group shows, *Every Fiber of My Being*, *All That You Leave Behind*, and *Life's Odd Ephemera*, I have explored the qualities of textile that make it essential to our survival but also indispensable as material for art and decoration. Stitching—or drawing with thread—leaves an imprint of the maker's movements while unfolding, stretching, cutting, and molding thoughts. In a time of rapid communication, disposable objects, and the machine-made, craftivists and artists ask the question, "What does what we make say about who we are?" By becoming thread-conscious, not only do we see strands of narrative woven into our material world, but we also see the materiality of our memories. These exhibits tend to focus on themes around the documentation and embellishment of collections to craft ambiguous narratives. Art tells us partial truths. We craft ourselves through word and deed, but in our personal spaces, it can be easy to accommodate multiple, sometimes contradictory, narratives to find comfort in and make meaning out of our lives. With objects and text fragments reproduced in textile and thread, the work continually returns to the inherent conflict between authenticity and representation. Stitching recalls the intervention and embellishment of the artist. Given the communal nature of most crafts, I find that exhibiting with artists who work in different materials creates an interesting dialogue.

ACTIVISM IS EASIER WITH ALLIES

I was drowning in the polluted swamp of Trump's Twitter feed when I discovered Molly Jong-Fast tweeting about the resulting stench. To read Molly's tweets is to have someone toss you a life buoy. To stitch Molly's words is to be pulled up onto the deck of a rescue boat. It's hard to find companionship when you spend almost every single day, as I did for years, stitching "daily doilies" about Trump's politics.

Molly has the uncanny ability to be perpetually anxious, relentlessly curious, fully committed to the study of Trump's insane children, immediately outraged, apologetic when appropriate, constantly apoplectic, and wise in the face of idiocy. In a medium with a limited number of words, she has an unlimited capacity to absorb our world. Every weekend I pick one of her tweets to stitch, and we collaborate on a "Mondays with Molly" post. The "tweet to textile to tweet" translation is a moment of pause in a relentless 24-7 cycle of disposable news. Our consumption of politics and current affairs feels like running a marathon with a sprinter's stride. The pace is truly relentless. The deliberative process of stitching her words into textiles allows for a material record of current events and an opportunity to reflect on the recent past.

Every era has writers and journalists who have the ability to memorialize events in real time. They guide us through uncertainty even though they are uncertain. (To be otherwise these days would be impossible.) As an artist stitching politics, I rely on Molly's perspective to navigate the news. I trust her because she takes her job seriously, but not herself. She is quick to admit it when she gets something wrong (which, unlike our former president, she is able to do). She's not afraid to attract all sorts of unwanted attention (including death threats), and she knows when a well-timed pet photo can offer much-

needed relief. When working with Molly's material, I feel a sense of joy in protest, a faith in quick intelligence, and gratitude for her company.

As a final note about your practice in and out of the studio, encouragement comes in different forms, and I find good criticism very helpful. If the feedback-shoe fits, wear it. If it doesn't, throw it out. I took these notes from the curator Francesca Consagra during a studio visit:

- Two ways to play it: safe or dangerous.
- What's going to make you stronger? Your work stronger?
- Go where your heart is.
- Learn to talk about your work.
- What are you equipped for? Don't worry about pleasing people. Learn to survive on little.
- Get in touch with yourself.
- Read books.
- Don't get obsessive.
- Fake it a little, even as an amateur.
- Don't tell stories about yourself.
- What are you going to spend your energy on?
- What's the push and pull?
- Listen and think about what people are saying to you. Stitch the disparate parts.

Francesca lost her fight against ovarian cancer a couple of years later. I return to her advice often, finding new wisdom in her words. I hope you find it helpful. Crafting our friendships, memories, and ways of remembering can help ease our pain. Making is a gift to be shared.

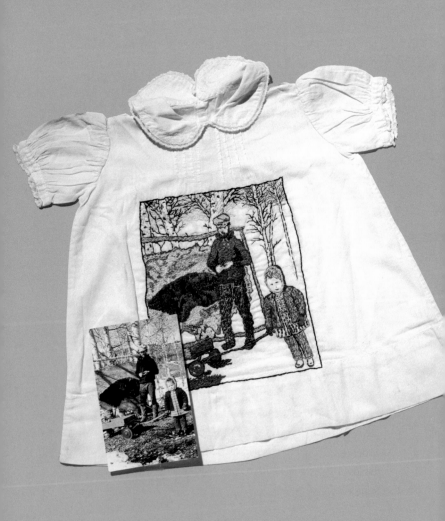

CONCLUSION

WHAT DO WE MAKE FROM HERE?

On September 14, 2022, in the middle of the night, I got a phone call telling me that my father, who had been suffering from Alzheimer's disease, died alone in a nursing home in Northern British Columbia. At the time, I was swept up in the excitement of my show, *Uncommon Threads: The Tweets of Molly Jong-Fast* at Planthouse Gallery in New York City. My father and his illness had seemed a world away in another country. It had been my intention to go home to spend time with him after the opening week, but I was out of time. Early the next morning, before getting on a train and then plane to go home, I walked to the gallery to look at all my stitched pieces on the walls. What I would have given to have shared that show with my father. What I would have given for more time with him! In the weeks after that, and to this day, I rely on making to help me through this new wilderness without him. Whatever purpose I found in my work before this loss, I have doubled down since. Making was a way of being, now being is a way of making.

These habits, this approach to the world, can help us through our darkest moments. After my father's death, my brother and a friend made his casket by hand. We picked wild flowers on his property and stuffed them into jam jars for his celebration of life. I made a wreath of juniper branches from the ridge on his property for the podium. We lit campfires out of wood we chopped on the ridge (once the fire ban was lifted!). We touched everything in his house as we divided it into piles: save, dump, take home with us. We especially touched the tools in the large wooden trunk that he used to build a log cabin in the wilderness over fifty years ago. I stitched letters from my father and his family members into my pieces for the show *Life's Odd Ephemera*. I believe we are all searching for ways to remember, honor, to stay here just a little longer, and a craft allows us to do that.

So where does this leave me today? Leave us? Sometimes it can feel like the world is either on fire, flooding, or at war. In the United States alone, women are fighting for bodily autonomy (again), a pandemic changed our lives, trans people fight for equal rights, the murder of George Floyd shocks us awake, gun violence plagues us, mental health and addiction issues touch all of us sooner or later, and a former president sparks an insurrection and then runs for president again. The known and the unknown alike frighten us. There must be some way out of here.

But there must be some way to be here. Now. My work, and the work of the makers in this book, is about being here together. Their craft grounds them in this moment in time. My hope is that you will find a way, by reading and sharing this book with your community, to tug at the threads of your memories, search your personal history, believe in a way of being together, imagine new ways of seeing things, and experience small sparks of inspiration that travel from your head

to your heart to your hands. And there it will be, a piece of art, a song, a cookie, or whatever you make, to reflect back on the way in which you were present. You are present. Making is a balm. It can soothe us. As we make art, it makes us. Better. Kinder. And more connected to ourselves and each other.

In 2014, my father gave me a copy of *Art as Therapy* by Alain de Botton, and John Armstrong inscribed it: "For Diana, Keep doing art. Dad."

For you, keep crafting a better world.

Three generations: my daughter's stitching of my father's inscription to me in de Botton's book.

PARTNERS
IN THREAD

Partners in Thread, with gratitude:

Tom Buri, Deborah Brakeley, Russell Buri, Greg Buri, Alex Buri, Kira Hoffman, Build Peace, Nelson Hancock, Liz Bernbach, Maria Evans and the Arts Council of Princeton, Amanda Benchley, Molly Jong-Fast, Danielle Hogan, Sam Potts, Rachelle Hruska MacPhearson, Lingua Franca, Jennifer Senior, Gisele Fetterman, Dani Shapiro, Maira Kalman, Rosanne Cash, Natalie Chanin, Project Threadways, Mandy Patinkin, Kate Bowler (Gwen & Harriet), Suleika Jaouad, the Isolation Journals (Carmen & Hollynn), John McPhee, Lindsey Aborn, Shannon Downey, Wendy MacNaughton, Katie Michel, Planthouse Gallery, Christine O'Donnell, ShowUp Gallery, Zen Hospice Project, Roz Chast, Barb Webb, Lisa Birnbach, Jamie Lee Curtis, Brownstone Cowboys, Emma Roberts, Belletrist, Barb Hostetter, Betsy Blumenthal, Leslie Walker, Samantha Fremont-Smith, Tatter Blue Library, Textile Arts Center, Nick Paumgarten, Anna Russell, Sarah Cascone, MILCK, Lucy Dacus, Dan Mangan, David Diliberto, Jim Acosta, Rachel Vindman, Alissa Quart, the Economic Hardship Reporting Project, Gabrielle Stanley Blair, AGirlHasNoPresident, Claire Messud, Winky Lewis, Jocelyn Lee, Speedwell Contemporary, Jerry Saltz, Roberta Smith, Cameron Manning and Tom Wright, Melanie and Peter Mullan, Amelia Wright, Rob and Meg Ramsdell, Caroline and Helmut Weymar, Merilyn Rovira, Rebecca Morton, Draper James, Molly McNearney, Jimmy Kimmel, 'Sconset Meditation Group, Tiya Miles, Mary Loria, Libertine, Lesley M. M. Blume, Martha Plimpton and A is for . . . , the Museum of Arts and Design, Pete Souza, Danielle Krysa, Alison Cornyn and *Incorrigibles*, Rob Shea,

Hyatt Bass, Greta Austin, Lara Johnson, Sarah Terry, Tanya Selvaratnam, Pat Moss, John Penotti, Debbie Millman, Deb Amos, Annabella Sciorra, *Mother Tongue Magazine*, Joyce Carol Oates, Danielle Otis. Meg Thompson for her creative agency as my agent, Emma Effinger for her (seemingly) effortless editing: the best creative team a crafter could want in a foxhole. The many writers who have shared their words with me. The thousands of people who have made *Tiny Pricks Project* the best place to work since 2018. And the generous contributors to this book . . . thank you for sharing your lives with us.

SPECIAL IMAGE PERMISSIONS

"Be Best" page 14 stitched by Roz Chast for *Tiny Pricks Project*, photograph by Nelson Hancock; Iceberg photo page 23 by Camille Seaman; photos pages 32 and 33 copyright © Guerrilla Girls, courtesy guerrillagirls.com; page 39 © BFA; Love cookie photo page 42 courtesy of Alexandra Grant; "Essential Questions" page 44 stitched by Liza Weymar, photograph by Nelson Hancock; Seasonal Fire Calendar page 57 courtesy of Dr. Kira Hoffman, Amy Cardinal Christianson, and Alexandra Langwieder; Welcome Blanket photos pages 58, 60, and 62 courtesy of Jayna Zweiman; Bans off Our Books Graphic page 67 designed by Ash + Chess for Out of Print, Banned Book Week 2023; Ashley's Sack photo page 68 courtesy of the Middleton Place Foundation, Charleston, South Carolina; Poem photo page 74 by Robert Rausch; Project Threadways photo page 76 courtesy of Natalie Chanin; SSJA illustrations pages 91 and 92 by Liza Weymar; Pussy Riot photo page 107 by James Pawlish; Chocolate Vulvas page 108 courtesy of Lagusta Yearwood; Mini museum photo page 112 courtesy of Danielle Krysa; Now and Forever Windows page 116 courtesy of the Washington National Cathedral; Gabrielle Blair arguments pages 124 illustrated by Liza Weymar; Mx.Mona photo page 134 by Evin Nguyen (@evin.ng); and MOTHER piece design page 148 by *Mother Tongue Magazine.* All other photography by Nelson Hancock. All textile art by Diana Weymar, unless otherwise noted.

ABOUT
THE AUTHOR

Diana Weymar grew up in the wilderness of British Columbia, studied creative writing at Princeton University, and worked in film in New York City. For the past decade, she has been threading the needle to create a material record of our times. Both on social media and in person, she has encouraged thousands of people to find their own creative path through personal and political challenges.

She is the creator and curator of the public art projects *Interwoven Stories* and *Tiny Pricks Project*. Her collaborations and exhibits bring people together around textile and embroidery to share personal stories and discuss political issues. She has worked or collaborated with Build Peace (Nicosia, Bogotá, Zurich, Belfast, San Diego), Arts Council of Princeton, Nantucket Atheneum, W.E.B. Du Bois Center at UMass Amherst, University of Puget Sound, Zen Hospice Project, Open Arts Space (Damascus, Syria), Trans Tipping Point Project, New York Textile Month, Alison Cornyn's *Incorrigibles* project, Syrian journalist and activist Mansour al-Omari, Princeton University Concerts' Healing with Music series, Project Threadways, Alabama Chanin, Open Society Foundations, the Isolation Journals, Kate Bowler, Economic Hardship Reporting Project, Culture House,

the Fetterman campaign, Speedwell Contemporary, ShowUp Gallery, Planthouse Gallery, Molly Jong-Fast, Lingua Franca, Abortion Access Front, #notalonechallenge, Brownstone Cowboys, Priscilla Gilman, Craftland (Providence), the Anne Reid '72 Art Gallery (Princeton Day School), Politicon, Princeton Alumni Weekly, XChanges Gallery (Victoria, BC), the Mule Gallery (San Francisco), She Roars (Princeton University), Mariboe Gallery (the Peddie School), the Smithers Art Gallery, Textile Arts Center, and many others. Her work is also in private collections.

You can follow her on Instagram @tinypricksproject. Her website is tinypricksproject.com.

HarperCollins books may be purchased for educational, business,
or sales promotional use. For information, please email the Special
Markets Department at SPsales@harpercollins.com

FIRST EDITION

DESIGNED BY RENATA DE OLIVEIRA

Library of Congress Cataloging-in-Publication Data has been applied for.

ISBN 978-0-06-338928-1

24 25 26 27 28 TC 10 9 8 7 6 5 4 3 2 1